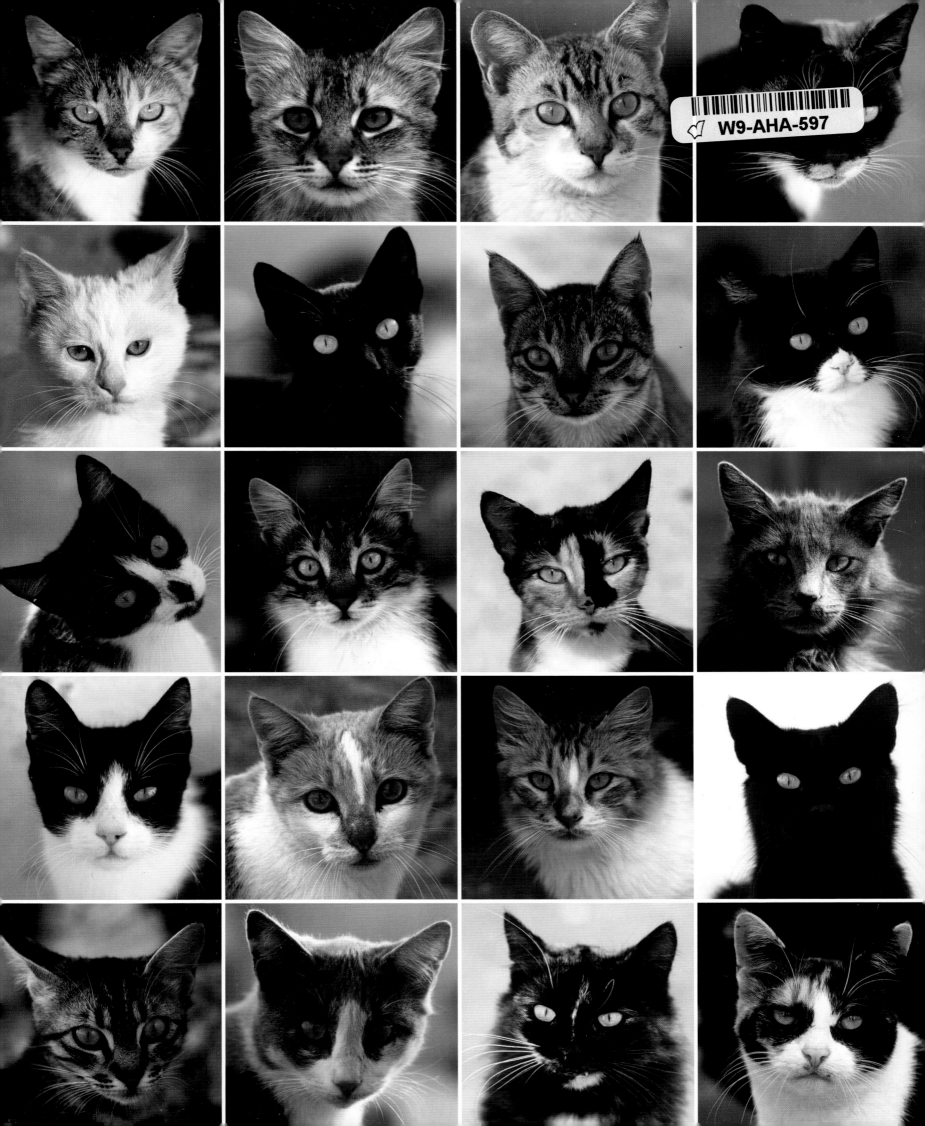

W9-AHA-597

CATS

Designed by Jay Colvin
Production Manager: Steve Baker

Library of Congress Cataloging-in-Publication Data:
Silvester, Hans Walter.
A child's guide to cats / Hans Silvester ; text, Hubert Comte ; illustrations, Sandra Lefrançois.
p. cm.
Includes bibliographical references and index.
ISBN 0-8109-5957-7
1. Photography of cats—Greece—Mykonos Island. 2. Cats—Greece—Mykonos Island—Pictorial works. I. Comte, Hubert, 1933-
II. Title.

TR729.C3S55 2005
636.8'0022'2—dc22
2005011795

Printed and bound in Belguim
10 9 8 7 6 5 4 3 2 1

Harry N. Abrams, Inc.
100 Fifth Avenue
New York, NY 10011
www.abramsbooks.com

Abrams is a subsidiary of

LA MARTINIÈRE
GROUPE

Hans Silvester

CATS

**Text by
Hubert Comte**

**Illustrations by
Sandra Lefrançois**

HARRY N. ABRAMS, INC., PUBLISHERS

CONTENTS

Cats are . . . curious 12–13

Cats are . . . playful 14–15

Cats are . . . courageous 16–17

Cats are . . . acrobats 18–19

Cats are . . . caring 20–21

Cats are . . . seductive 22–23

Cats are . . . tightrope walkers 24–25

Cats are . . . watchful . 26–27

Cats are . . . provocative . 28–29

Cats are . . . thieves . 30–31

Cats are . . . colorful . 32–33

Cats are . . . amorous . 34–35

Cats are . . . family animals . 36–37

Cats are . . . lazy . 38–39

Cats are . . . patient . 40–41

Cats are . . . protective 42–43

Cats are . . . organized 44–45

Cats are . . . man's best friend 46–47

Cats are . . . fierce . 48–49

Cats are . . . sleepyheads . 50–51

Cats are . . . clean . 52–53

Cats are . . . thoughtful . 54–55

Cats are . . . comfort loving . 56–57

Cats are . . . cautious . 58–59

Cats are . . . hunters . 60–61

Cats are . . . artistic . 62–63

Cats can be . . . naïve . 64–65

Cats are . . . great yawners . 66–67

Cats are (sometimes) . . . a dog's best friend . 68–69

Cats are . . . quarrelsome . 70–71

Cats are . . . invasive . 72–73

Cats are . . . affectionate . 74–75

Photographing the cats of the Greek islands

Where did I get the idea for this fascinating project?
As with many things in life, it was just a question of luck
opening the door of opportunity.

I had traveled to the Greek islands in order to photograph the doves and dovecotes living on the island of Tinos, but I was trapped for two long days on the island of Mykonos by off-coast storms. Hoping to make the most of the unexpected layover, I decided to take a stroll about the island. I had my trusty Leica camera in my hand, in case anything interesting should happen to cross my path. After all, you never know what you might see.

What could be more pleasant than spending a day wandering through a labyrinth of narrow, white-washed streets between layers of white terraces?

There was an air of peaceful emptiness—the adults were either at work or busy with domestic tasks, and the children were at school. Yet I was aware of a sometimes furtive, sometimes nonchalant presence—the island's cats.

Tortoise shell, flecked, or spotted, brindled, tabby, or black as pitch, the cats I saw bounding about or padding along cautiously—when they weren't sleeping, that is—seemed to move with perfect ease. I immediately fell in love with them, and their grace, independence, and abundant personalities.

So I returned to these islands each year for the next seven years, for two or three months at a time, to document these creatures that had captivated me so completely.

This project took some time to complete for several reasons. First of all, there were many lost days to contend with. For example, when it's windy cats take shelter, since the wind blows away the scents in the air that help them orient themselves and provide them with other useful information. It also disturbs them by ruffling their ultra-sensitive coats. Secondly, if the fishermen have had a good catch, and the cats enjoy a plentiful feast as a result (see page 11), any kind of movement after so much eating is just out of the ques-

tion. On days like this, the cats simply find a place in the shade in which to lie down and digest their meals. There's not a cat to be seen. The sunlight can also cause problems. In the Greek Islands it can be very fierce, and its brightness produces far too much contrast for good photography. On such days, it is better to take advantage of the softer morning light, or to wait for the evening.

There were highs and lows during my time documenting the island cats: lucky encounters such as the day a female cat seemed to run along a wall just for my benefit, and bitter disappointments, such as those moments when I just didn't have the camera ready in time—I once missed photographing a touching family reunion. There were also some amazing replays of perfect cat moments that I had missed the first time, but which were then miraculously repeated as if frame by frame.

I watched, listened to, and got close to my subjects without attempting to tame them. And I learned a few lessons. One day, in a narrow street, a cat jumped from one roof to the next. It happened so quickly and unexpectedly that I didn't have time to react. What could I do? I checked my watch and, the next day, returned to the same place at exactly the same time. The athletic cat obligingly repeated the performance. I learned that cats are creatures of habit and tour their neighborhoods at exactly the same times each day, according to their internal

clocks. Food and affection also play an important part in the lives of these cats—they would often brush up against my legs, soon putting an end to any photography I attempted.

Finally, and most important, I figured out that, to the cats, there is a difference between a tourist who is just passing through, and a local, who is often regarded as a friend. The difference is that the friend returns. When I returned, the islanders, who had previously taken me for a "madman who chased cats," this time welcomed me with coffee and cakes, and introduced me to the new cats in their neighborhood. Cats have an extremely good memory for voices—and friendship, which they can sense. I got to know their families, their habits, and their ways of life. I would greet them softly, "Hi, there," as was befitting these old friends and faithful companions. I hope that the images in the following pages will encourage you to view these wonderful creatures with patience and understanding.

—Hans Silvester

Cats are . . . curious

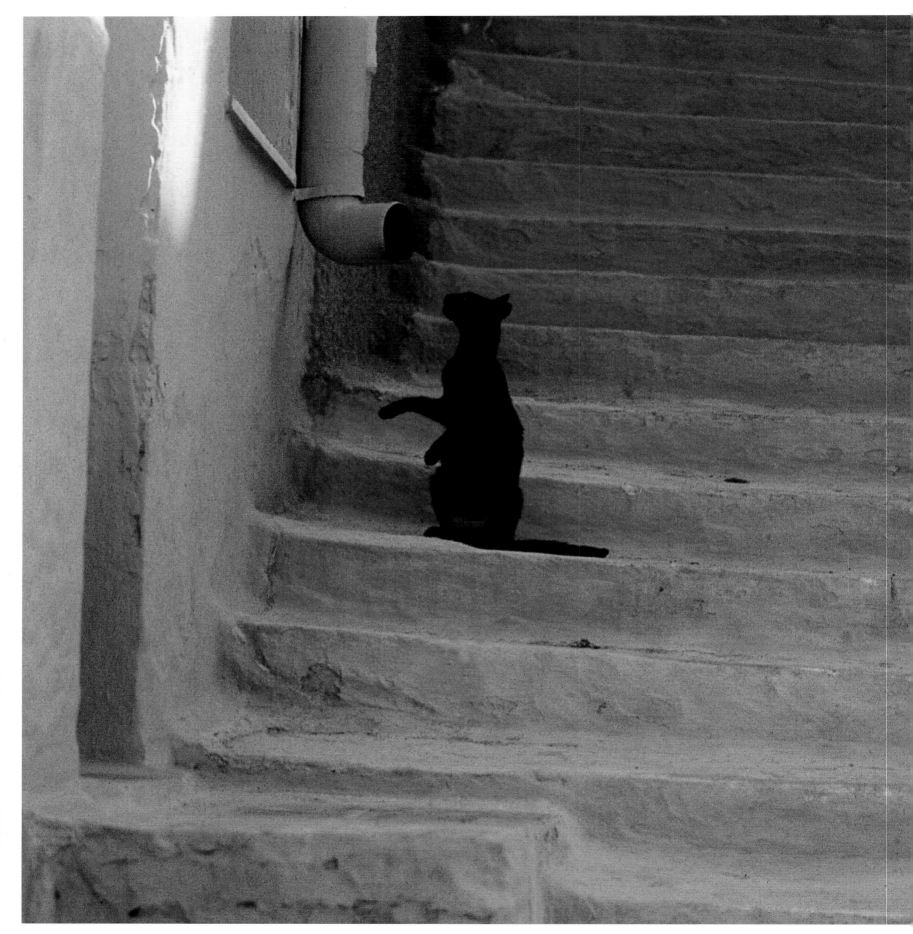

Popular belief has it that the tawny owl is a wise bird, its intelligence born of a strong curiosity. With a head than can rotate almost in a full circle and an unnerving, fixed gaze, it could certainly be called "curious." But when it comes to real curiosity, the tawny owl is no match for the watchful cat. The cat's ability to fix its attention so completely on something, whether large or small, is quite unique.

Cats are blessed with this skill for a number of reasons related to their species, size, and nature. The slightest movement of a blade of grass can reveal the presence of a small rodent to a feline hunter. Although it must seem like a giant to its prey, the cat itself is sometimes the prey of dogs and other animals, and so it needs to be alert at all times. The cat approaches new surroundings with great caution, meticulously assessing unfamiliar spaces using its senses of sight and smell.

Cats are . . . playful

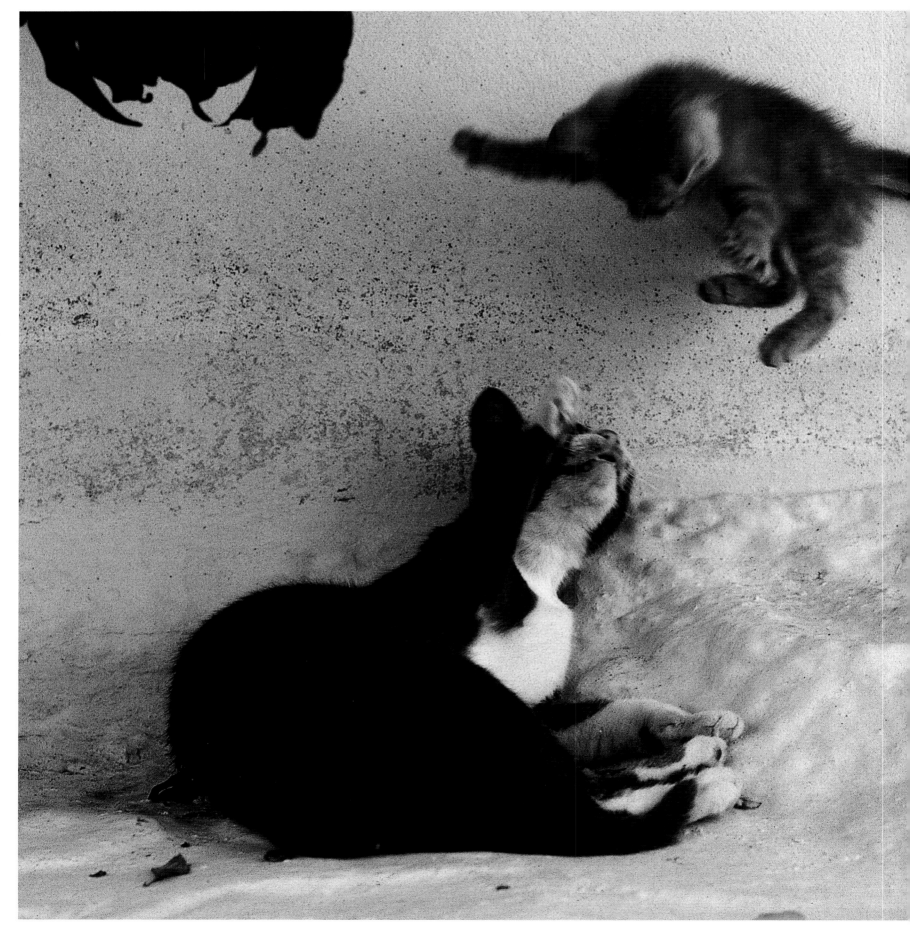

Play, an activity born out
of curiosity, is an integral part of a
cat's life, from infancy into old age.

The first games a mother cat plays with her kittens are a sort of test to see how well they can respond to heractions. What appear to be caresses and little cuffs of the mother's paw, are actually her complex method of identifying the most intelligent of the litter. Later, play becomes a form of exercise marking a new stage in the kittens' development. They learn to climb, roll, and fall onto all four feet, all skills that will be important to them as adults.

The mother gradually stops feeding them; and once they are fully weaned the games become more serious. For instance, young cats will pretend to kill small animals such as mice—and their initiation into hunting has begun. For people, play and make-believe is usually a form of escape, but for cats the act of play is a training process that enables them to successfully hunt and defend their territory.

Cats are . . . courageous

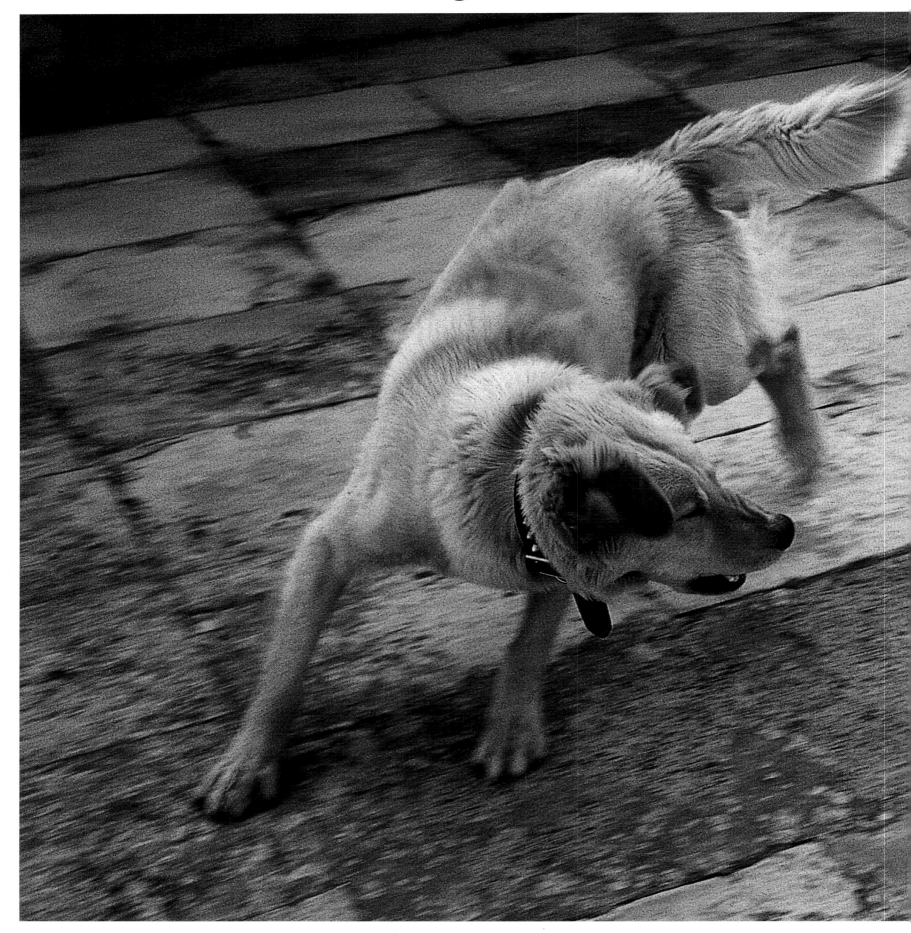

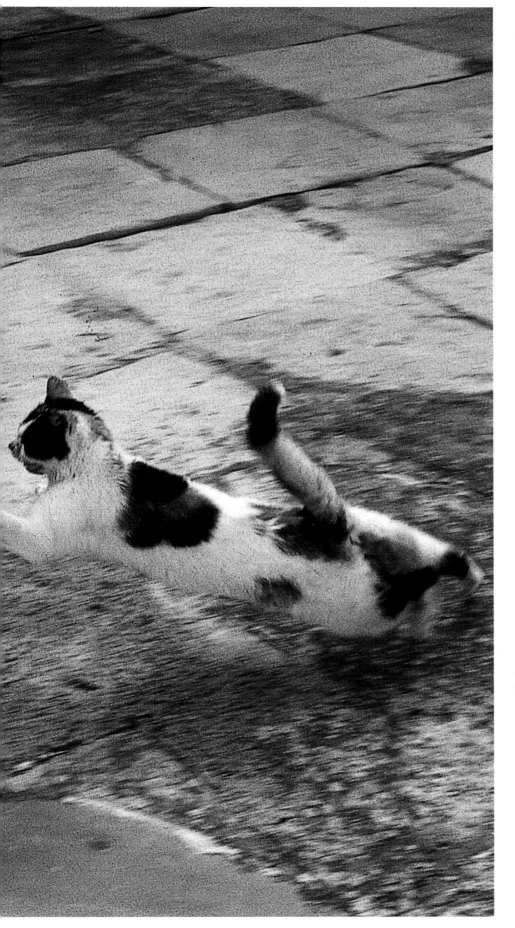

C lose your eyes for a moment and imagine you are a cat. It's a different world! The smallest house seems like a cathedral and people are giants. But if you play your cards right, you can get these giants to feed you, let you out at night, and let you back in again in the morning, on the condition that you don't steal their dinners of course! These giants, and even their children, are generally kind to cats.

However, the dog—a carnivore and a close relative of the wolf—is the guardian of the giants' homes and their livestock. It is the their loyal hunting companion, and is a cat's mortal enemy. Dogs run like athletes and have greater stamina than cats. The snap of their viselike jaws on a cat's back can be fatal. When confronted by a growling dog, a cat's only means of escape is often to climb a tree.

Cats, however, are extremely courageous. To defend her young, a female cat will confront a dog—and often win. And to defend his territory (usually about two and a half acres) a male cat will aggressively challenge other contenders of his species. The defeated cat will retreat to lick his wounds, the experience firmly etched in his memory.

Cats are . . . acrobats

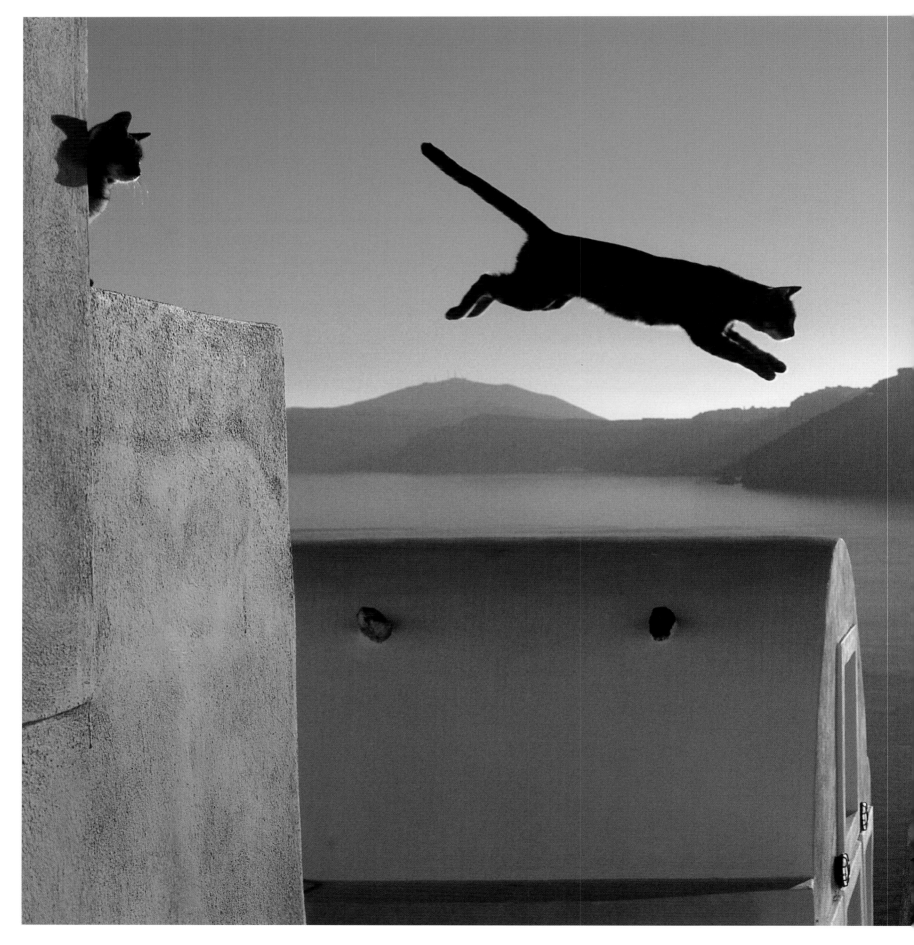

There's no doubt that cats are skilled acrobats. But, in spite of cats' great courage, they should not be made to perform dangerous feats just to prove their acrobatic skill! If you were to tell some people that a cat can land on its feet if dropped from a third-story window, they might try to experiment for themselves to see if this were true. The poor, unfortunate pussycat would suffer, wondering why it was subjected to such an alarming ordeal.

Even though cats are not likely to climb great heights, their agility and sense of balance almost match that of the squirrel, a champion when it comes to treetop antics, and the monkey, a height-defying daredevil. Cats just don't always like to show off these skills!

Cats are . . . caring

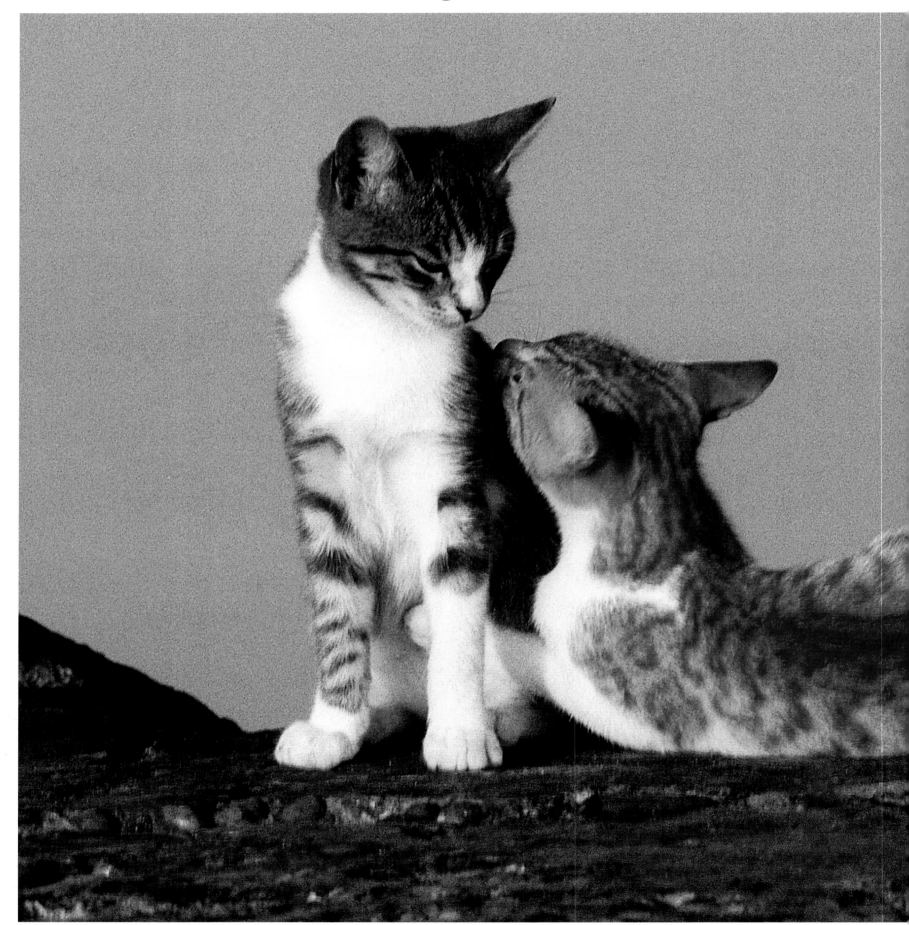

There are as many forms of affection as there are musical notes or colors in a box of paints.

This is as true for animals as it is for people—after all, we belong to the same family, even if it is extremely diverse. Both people and animals recognize the differences between, friendship, affection, and love. All these feelings share a common basis of happiness, gentleness, and tenderness. But they also share something more intuitive, and often forgotten—the protective warmth that is created by two bodies together, and the joy and hope experienced when a new being enters the world.

In their displays of companionship and affection as adults, cats seem to be rediscovering and rekindling their distant memories of maternal love.

Cats are . . . seductive

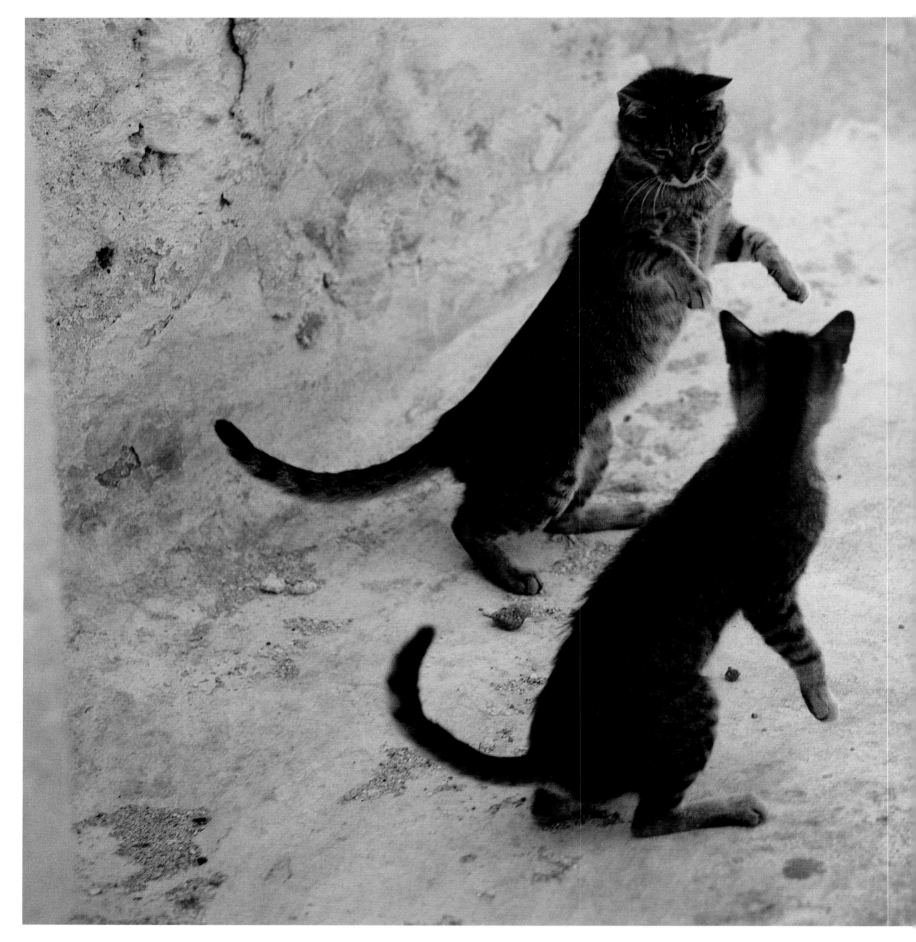

In this case, we do not mean "seductive" in reference to the relationships between male and female cats. As anyone who lives around cats is aware, relationships between males and females are regulated by nature, the changing seasons, and lunar months.

We are referring to how successfully cats exert their powers of seduction over people. Take, for example, a cat with a wounded leg that is hesitating between seeking help at two different houses. Let's say it chooses your house and you tend its wound. Realizing that it has found a good home, your new feline friend launches a full-on charm assault, licking your nose and dabbing at your cheeks with its paws. And suddenly, it's here to stay.

Or there's your neighbor's cat in the country. After flushing out a mouse from its hiding place, the cat presents its kill to you as if it were ticket to dinner. In fact, she is simply trying to please you, so that she may be able to have her litter in your barn.

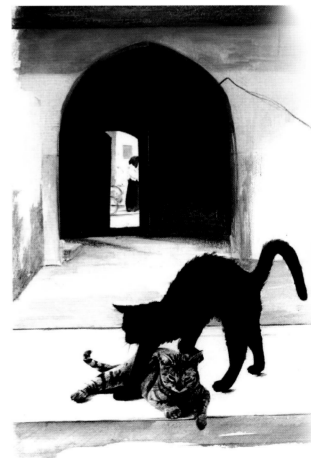

Cats are . . . tightrope walkers

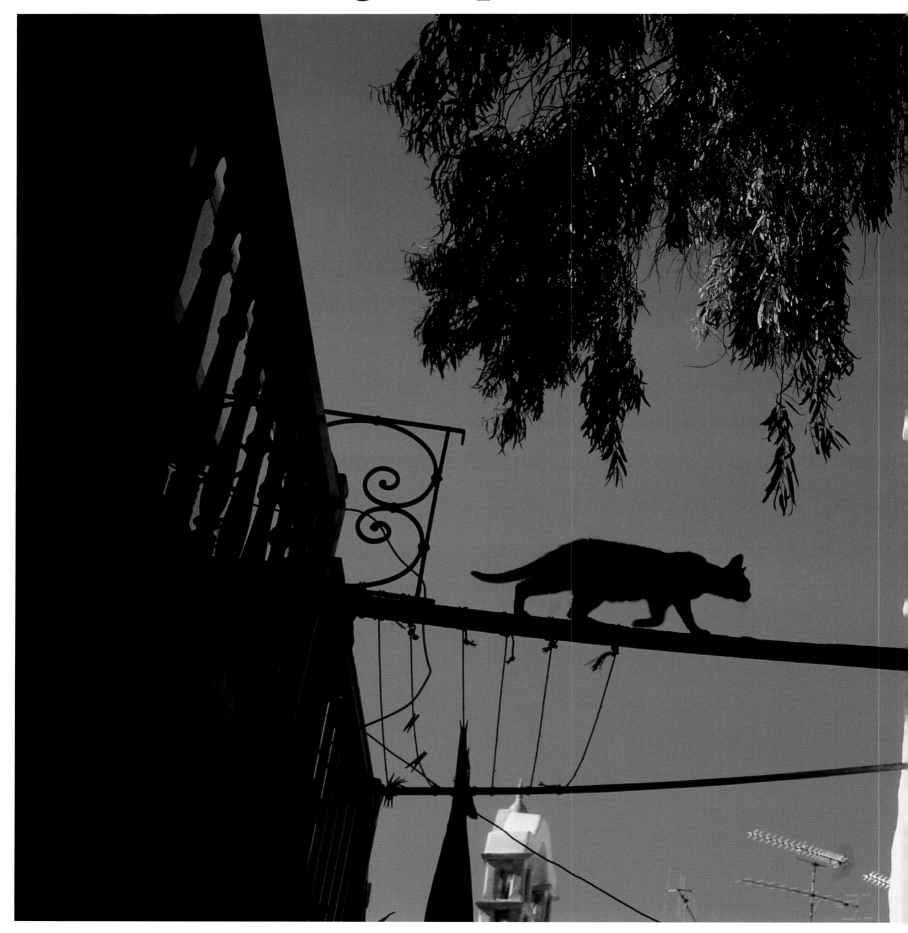

Although cats aren't quite as agile as squirrels, which can scoot across dozens of yards of electric cable, cats can quite easily walk down a "gangplank" several yards long and just the width of a broom handle.

Cats have a number of "aces up their sleeves" that ensure their success at such feats. First of all, they have great heads for heights—it is not uncommon for a cat to be seen leaning out of the tenth-floor window of a city apartment building, watching the ceaseless scurrying of the ant-sized humans below. They are also supremely self-confident—they know through experience and practice that if they miss their footing, they will miraculously land on their feet. Although they don't have actual suction, the pads of their paws give them a good grip, while their tails act as balancing poles, immediately compensating if they happen to overbalance. And finally, cats will never linger in a dangerous situation; they will always move on quickly to avoid falling.

Cats are . . . watchful

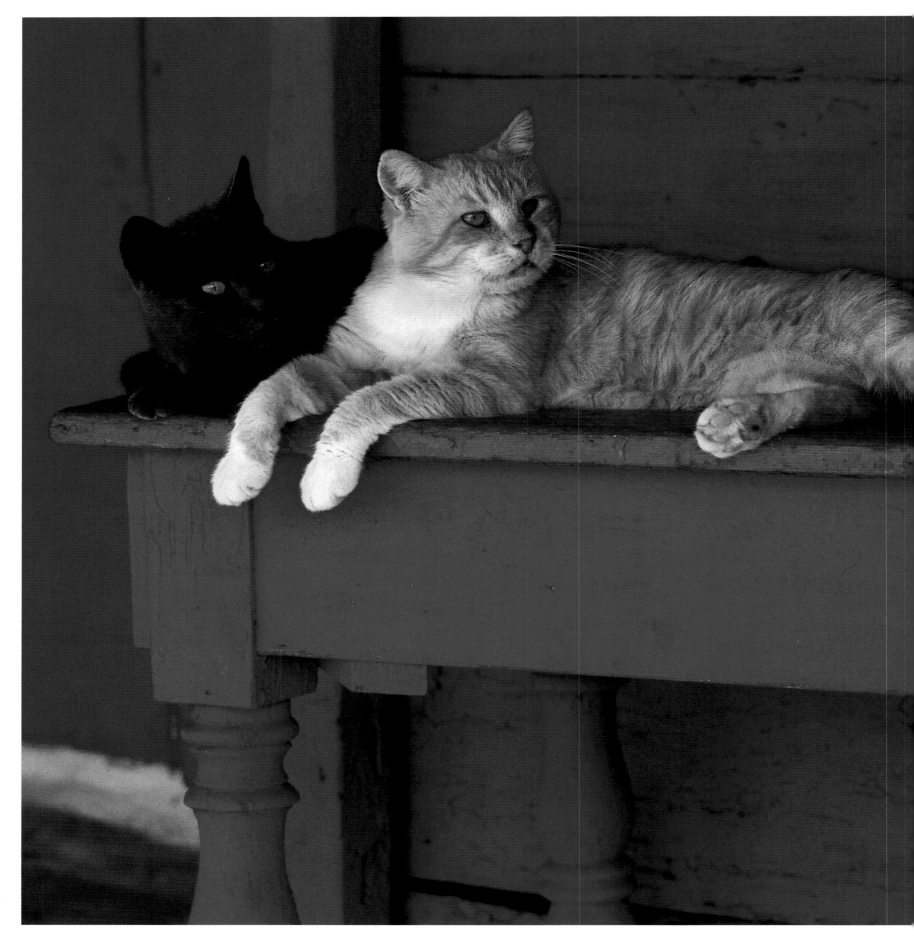

It's time for a siesta and these two cats have found a place to rest and unwind in the shade. The ginger cat is spreading out its back legs in order to prevent itself from getting too hot, and its front paws hang freely in space, to make the most of the slightest breath of air. This cat is the picture of relaxation, replenishing its strength while resting drowsily.

Although its muscles are relaxed, the same cannot be said of its gaze. It notices everything, both for the sheer pleasure of knowing what is going on, and to spot a potential opportunity. After all, there is one thing that this cat can never forget: It is a member of the wild, carnivorous feline race. Even the slightest quiver of a blade of grass can indicate the presence of prey.

This cat is keeping an eye out, just like Mr. Micawber in Charles Dickens's book *David Copperfield*, who was always expecting someone or something to turn up.

Cats are . . . provocative

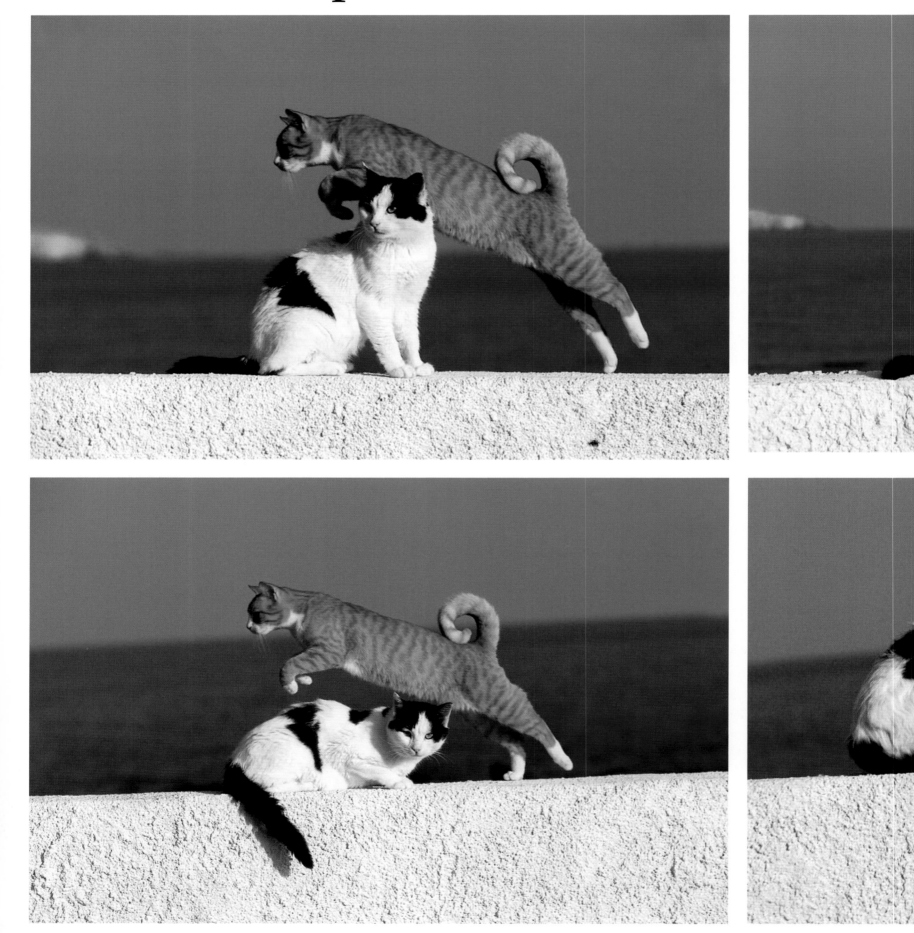

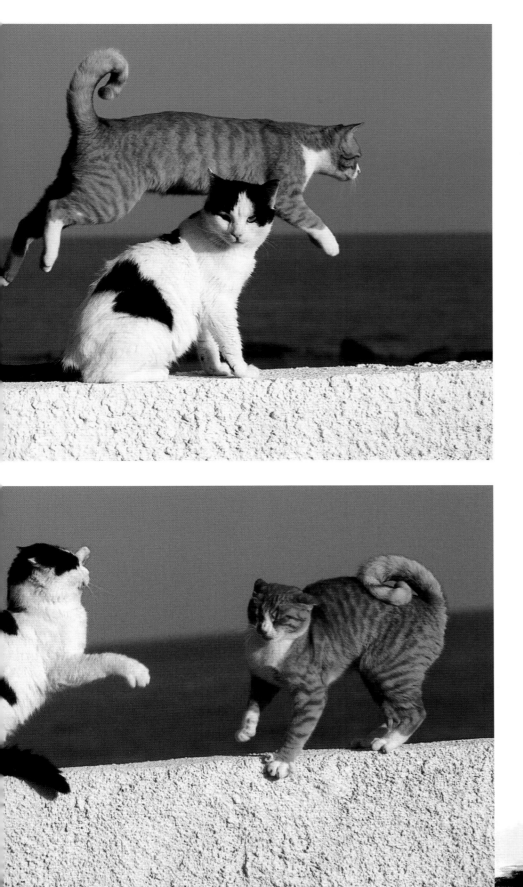

Cats are temperamental animals, and live for the moment. When they are eating, they give it their full attention. When they are hunting—or pretending to hunt—their concentration is deadly. Even the approach of a person cannot distract them from the task at hand. And when they want to take a nap, they find a safe, peaceful retreat where no one will disturb them.

Even when they have just woken up, cats are ready for action, even if only for the sheer joy of setting their bodies in motion. They are convinced that they are the dominant partner in their relationship with us, and they will provoke us until we are obliged to join their games. They will hypnotize us with a stare, or charge us in a mock attack, dancing around our feet to get us to play with them.

Cats are . . . thieves

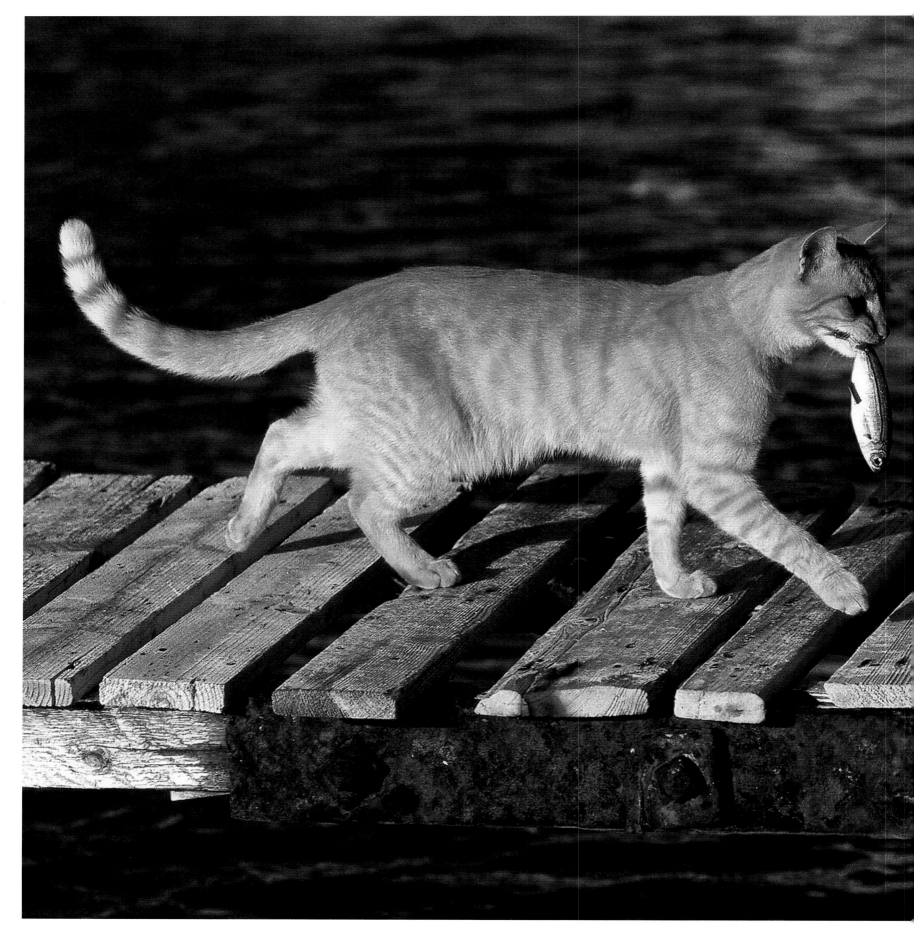

In ports all over the world—from Marseille to Monterey—fishermen sort their catches early in the morning before they are auctioned off, discarding the tiny crabs and fish that are too small to sell or have been damaged by the nets. The rule on the Greek islands is simple and firm: Cats are not allowed into peoples' houses. But a kind of pact has developed between fishermen and cats that is mutually beneficial: The fishermen turn the other way when cats make off with scraps left over from their catch. Cats, in turn, rid the port of rats and mice. As for keeping the cat population down, winter and nature take care of that—it's a survival of the fittest.

A capable carrier of lighter burdens, the cat to the left is making off with a fresh catch. In other countries, its catch might be a piece of liver stolen from the kitchen table.

Cats steal in order to eat. Unless they have been trained not to steal, they simply can't help it. It's an instinct that they can't control. They are hunters at heart and stealing is a particularly profitable form of hunting since it requires a lot less effort.

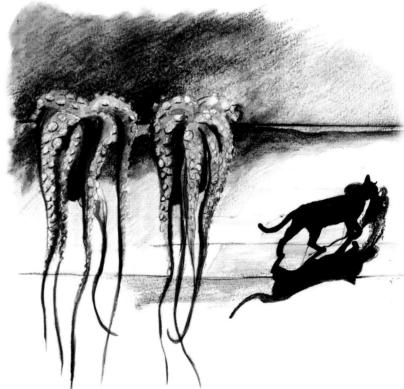

Cats are . . . colorful

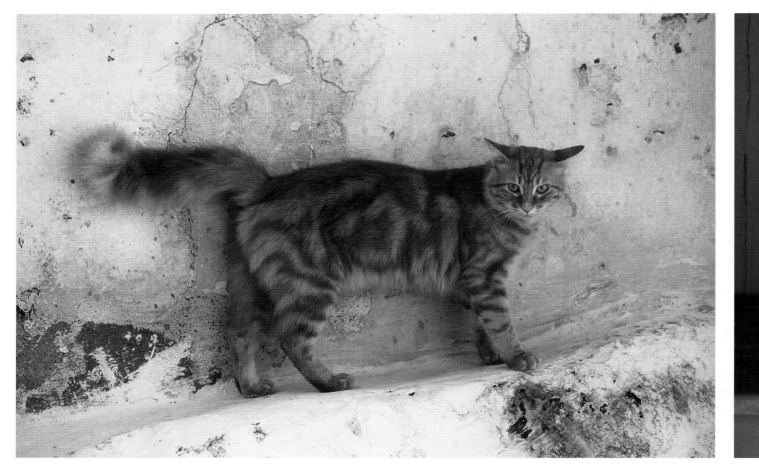

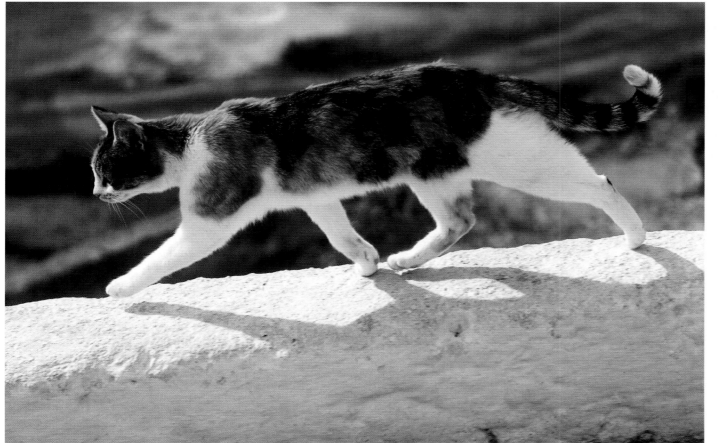

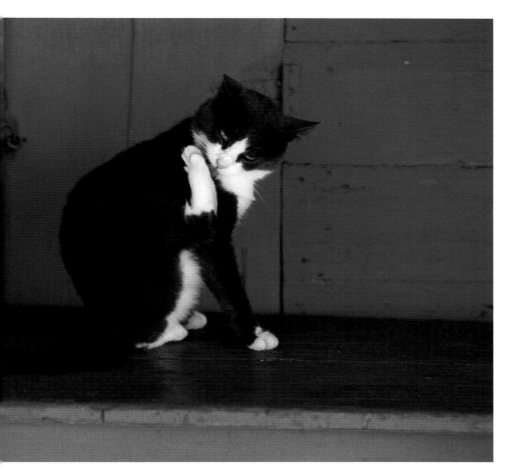

The range of colors and markings in cats' fur is infinite. A kitten's coat can have completely different colors and markings from its parents.

How many generations back do you think you would have to go to find an ancestor with the same markings as this beautiful tabby (top left)? Maybe one, maybe five. The tortoiseshell walking so purposefully (bottom left) has a coat covered with generous splashes of intermingled colors, reminiscent of ponies in cowboy films, or of a map in an atlas. Some cats' markings even have a comical edge to them: a black cat that looks as if it has dipped its nose in milk, a brown cat with a white medal around its neck, and a multicolored cat that looks like a schoolboy with a cap tilted over one eye. However, there is one certainty in the color lottery however: Only female cats have three-colored coats. Naturalists and zoologists have known about this for a long time, but are still not able to explain why.

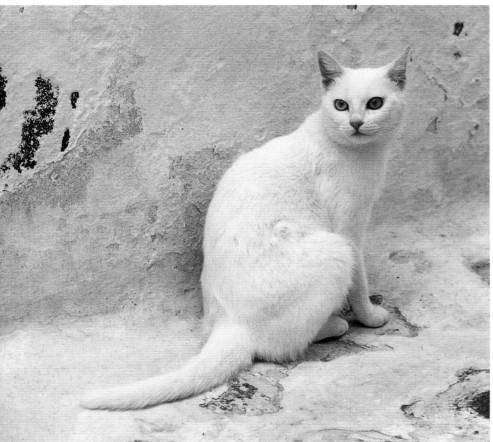

Cats are . . . amorous

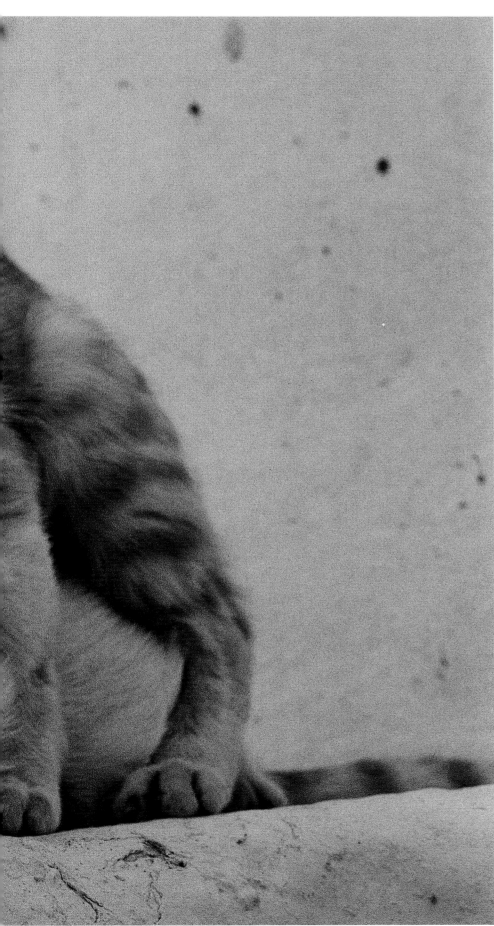

As humans pass out of adolescence, their bodies begin to take on the trappings of adulthood. Similarly, cats' bodies also begin to change as they grow into maturity and prepare to be parents themselves.

These physical changes take the female cat by surprise. She doesn't quite know what is happening—it's as if a fire is suddenly lit inside of her. She rolls on the ground mewing plaintively, an indication that she is ready to mate. One or more males will answer her cries and she will choose the strongest and most handsome. As a result, she will give birth to the strongest and fittest offspring possible. Thus the feline life cycle, subject to the practical but sometimes cruel laws of nature, will be perpetuated.

Cats are . . . family animals

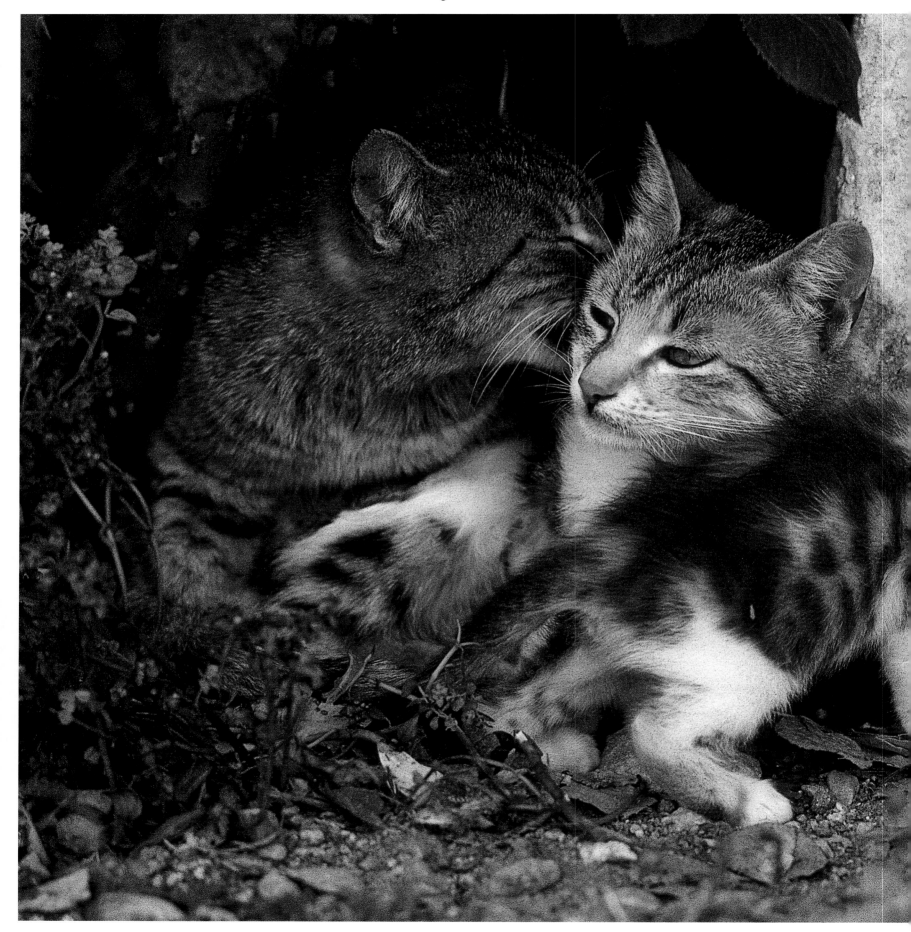

Cats are very focused on families, and the female cat is central to this instinct. Her patience knows no bounds and she has a wide range of mothering skills. She will turn into a tigress to defend her kittens. She is also an effective first-aid worker, and is a remarkable teacher of hunting techniques.

The cat family begins with the newborn kittens. In their first few days after birth, when they are still blind and clumsy, their squealing and mewing can give their presence away. Therefore it is essential that they be protected from all types of predators. The enterprising mother not only chooses a safe hiding place for her brood, but also keeps watch and, if she suspects her nest has been discovered, she moves the kittens one by one to a safer place, carrying them in her mouth. Although she has to go hunting for food, she always returns to the nest to feed her litter.

The mother plays with her kittens, amusing them with games that range from gentle and amusing to mock fights and hunting lessons. The kittens also learn how to get along together. This inventive, lively, and affectionate group forms a team that will always remember the importance of the family unit.

Cats are . . . lazy

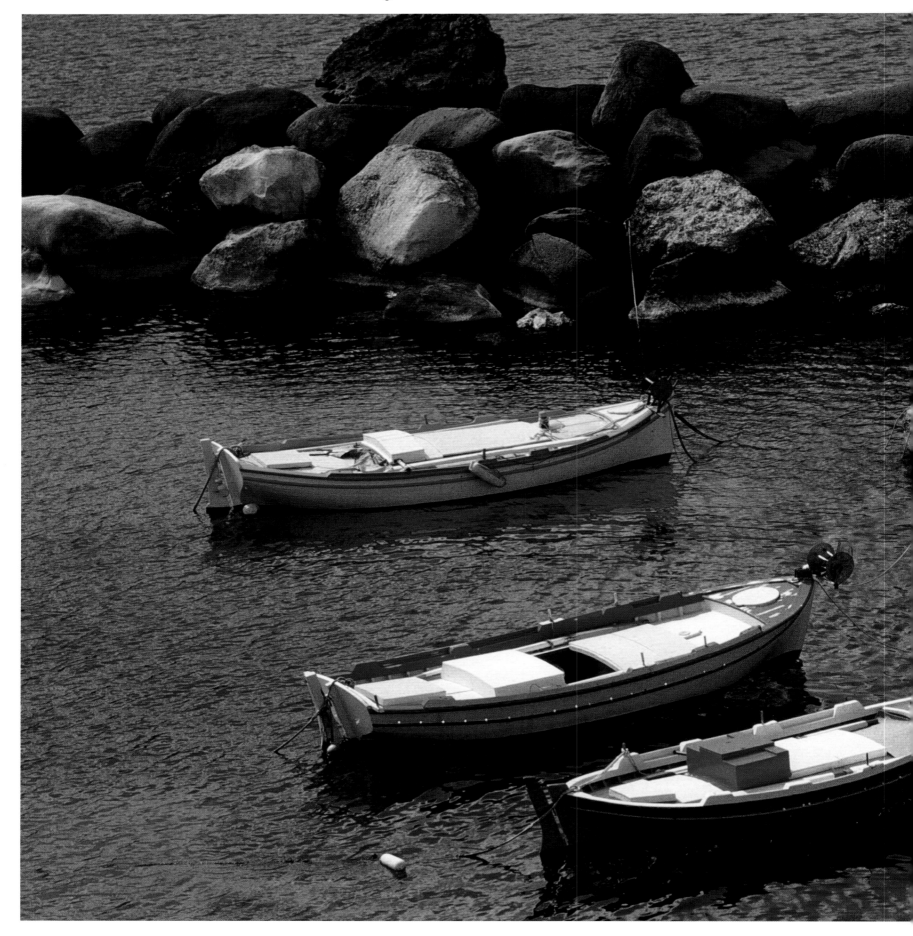

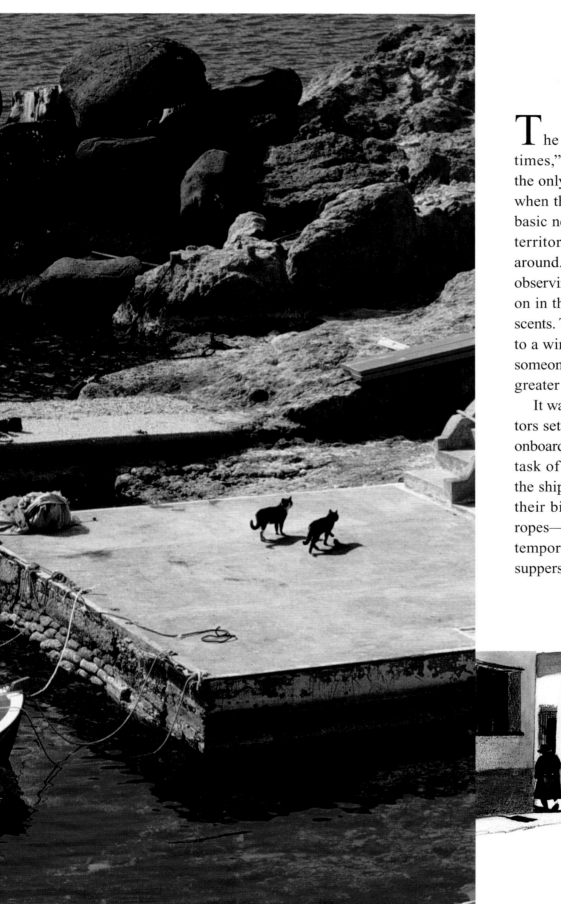

The expression, "I've been around the block a few times," is ideally suited to life on an island, where the only way off is to fly, swim, or sail. For this reason, when the cats of the Greek Islands have satisfied their basic needs—eating, sleeping, washing, inspecting their territory, and daydreaming—they like to simply loaf around. Despite this apparent laziness, they are always observing—watching to see what's new and what's going on in their environment. They sniff the air for any new scents. They might detect something that could lead them to a windfall, such as a little food that has fallen out of someone's bag. But the chances of a lucky find are much greater near the boats.

It was on these very quays that the Greek cats' ancestors set foot on dry land once more after a tour of duty onboard the fishing boats. They were paid in fish for their task of killing mice and rats that had stowed away on the ships. Sailors hated these rodents—which devoured their biscuits and sacks of corn, and chewed through ropes—as much as they did storms. And the cats, their temporary allies, have never forgotten those tasty fish suppers that they received in reward.

Cats are . . . patient

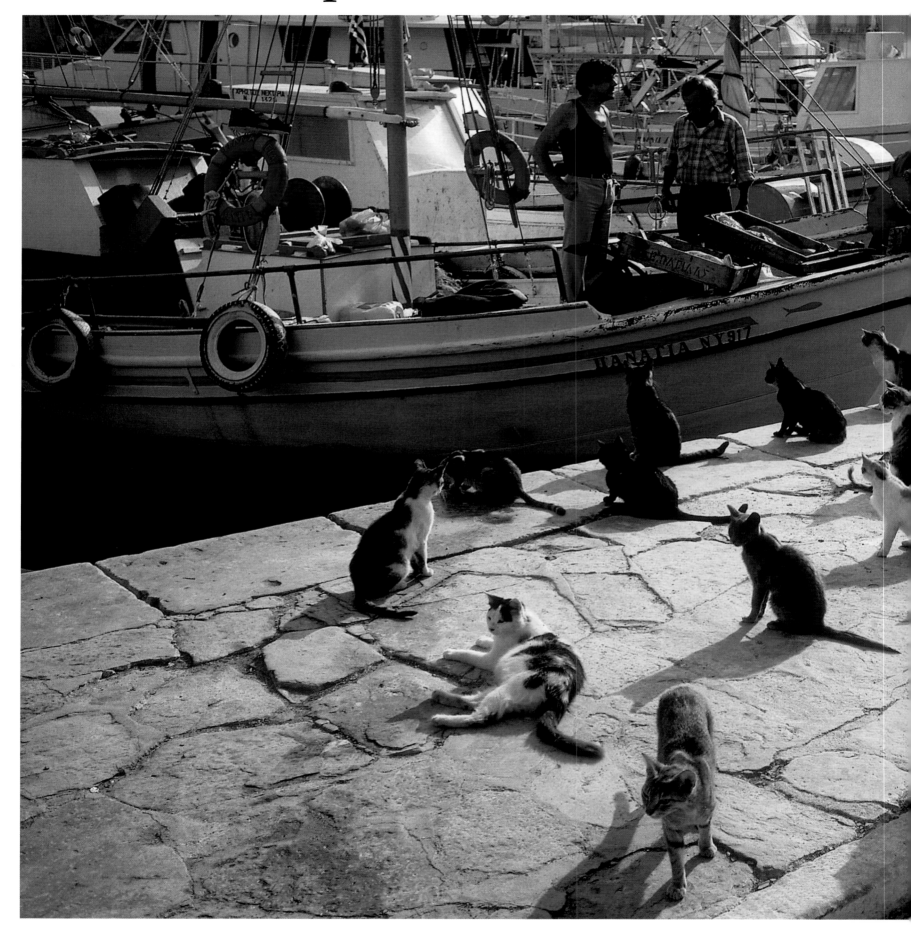

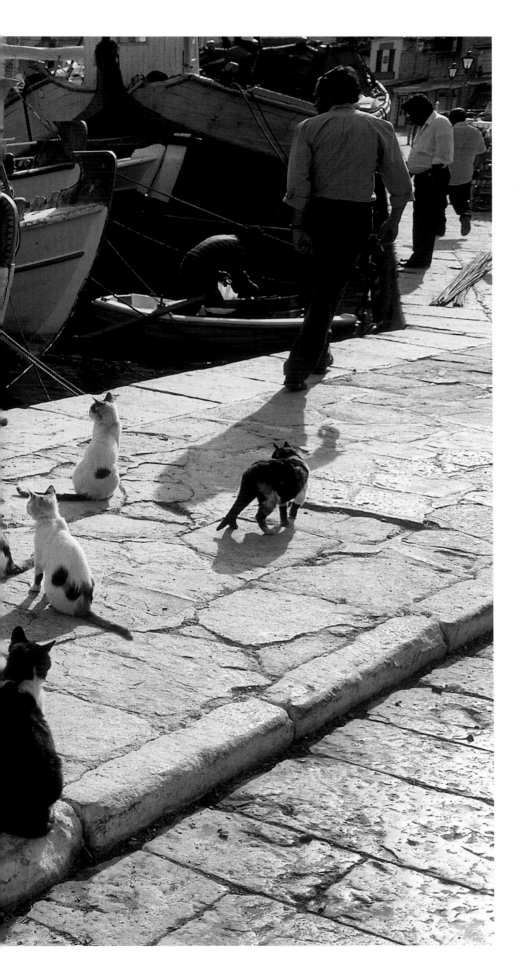

Cats are extremely disciplined in their behavior. The internal clocks in their tummies tell them when it's time to eat. Eager for food, the island cats arrive right on time on the quay that serves as their dining room. All their senses are on alert, giving them a whole host of information—the height of the sun in the sky, the sun's warmth on their fur, the sounds of the boats' engines, all the activity taking place on the previously sleepy quay.

However, cats are civilized creatures with great self-control. They will wait as long as it takes to get their fish dinner. Cats' behavior is nothing like that of dogs or pigs when they catch the scent of food, not to mention the behavior of jackals and vultures. Cats respect one another's personal space. They have learned by experience that there will be plenty for everyone. The fishermen will throw scraps of fish onto the stones of the quay—and perhaps the most succulent sardine will be thrown the furthest. Let's just wait and see . . .

Cats are . . . protective

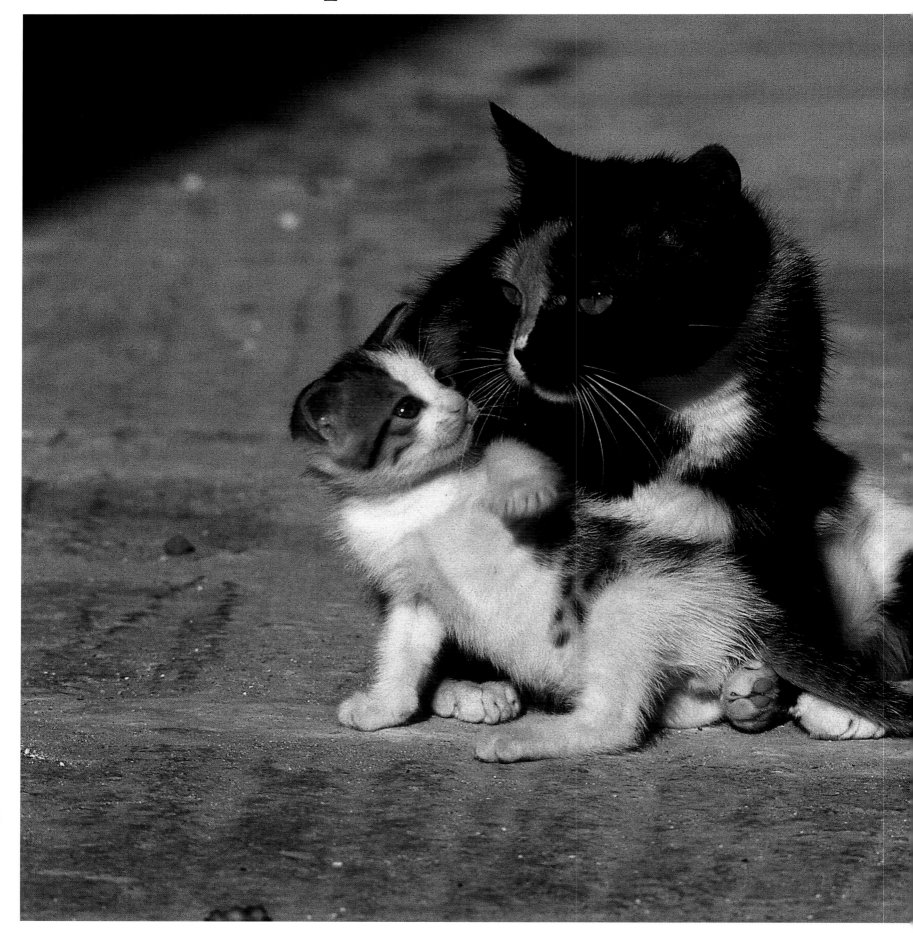

The instinct to protect the weaker members of the species is a strong part of a cat's emotional makeup. It is epitomized by the mother cat gently taking her kittens in her mouth one by one and moving them to a new hiding place to escape imminent danger. It is hard not to be moved by this display of love.

Cats are not protective of each other for personal advancement; they have no innate desire to dominate each other, as is the case with many people. Many people believe that cats never forget their mother's affection and the feeling of comfort and warmth that they experienced before they were thrown headlong into the struggle for food and survival. You don't need to be a scientific expert to realize that all living creatures have just one overriding aim: ensuring the future of their species.

Cats are . . . organized

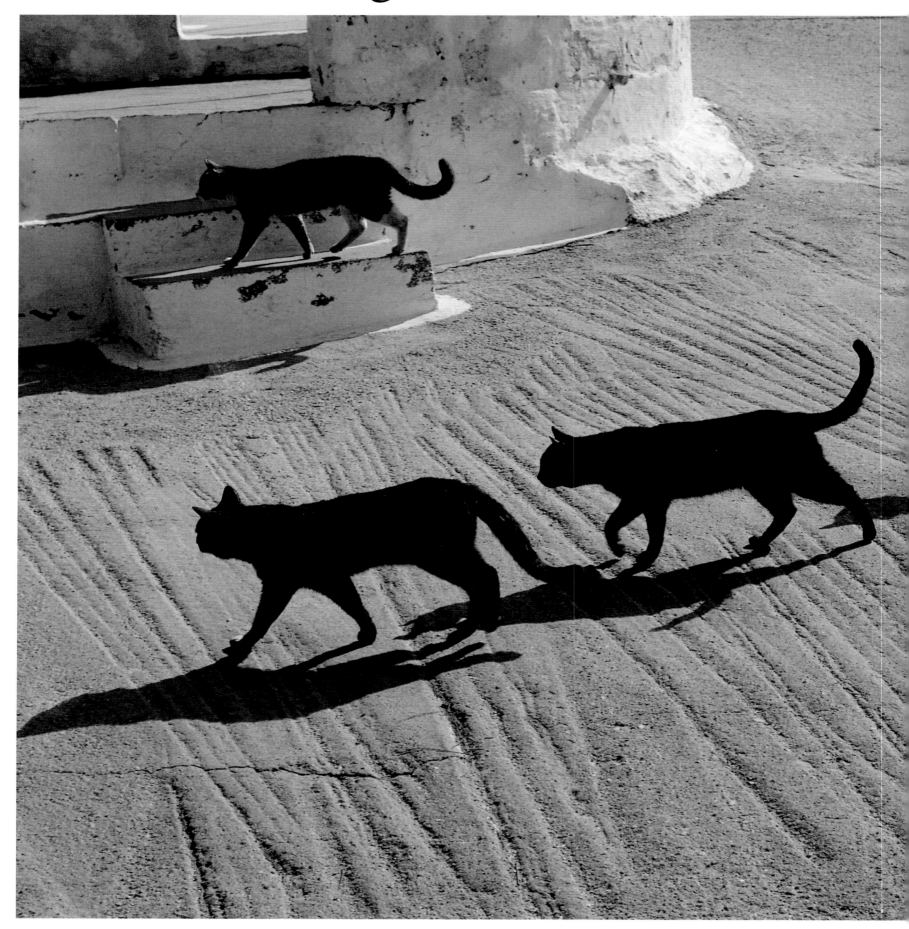

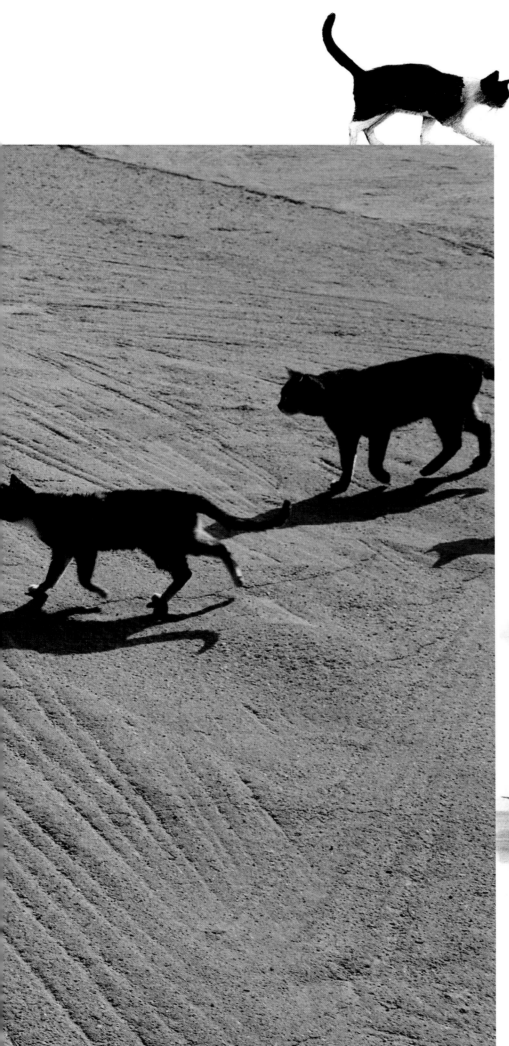

Thanks to the patient research of enterprising scientists and naturalists, and the skill of cameramen and photographers, we now know a great deal about the habits and social interactions of animals. From field mice to turtledoves to buzzards, animals all have their own specific territories, and cats are no different. They won't stray more than half a mile from their home base, obeying the unwritten rules that govern their province. Cats are contemplative creatures and are very selective when it comes to choosing a lookout post. They like high places that allow them to survey the scene from an elevated position. They also prefer open vantage points so that they can see more of what's going on, and with their super-sensitive hearing they can identify any approaching danger. They prefer to avoid loud noise since this can drown out any interesting sounds. When hunting, a cat can locate a mouse or vole from a distance by the sound of its scratching and gnawing, even if it can't see the creature.

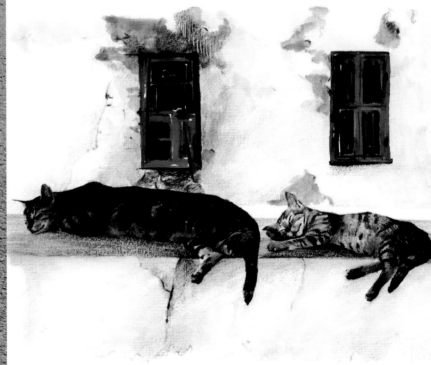

Cats are . . . man's best friend

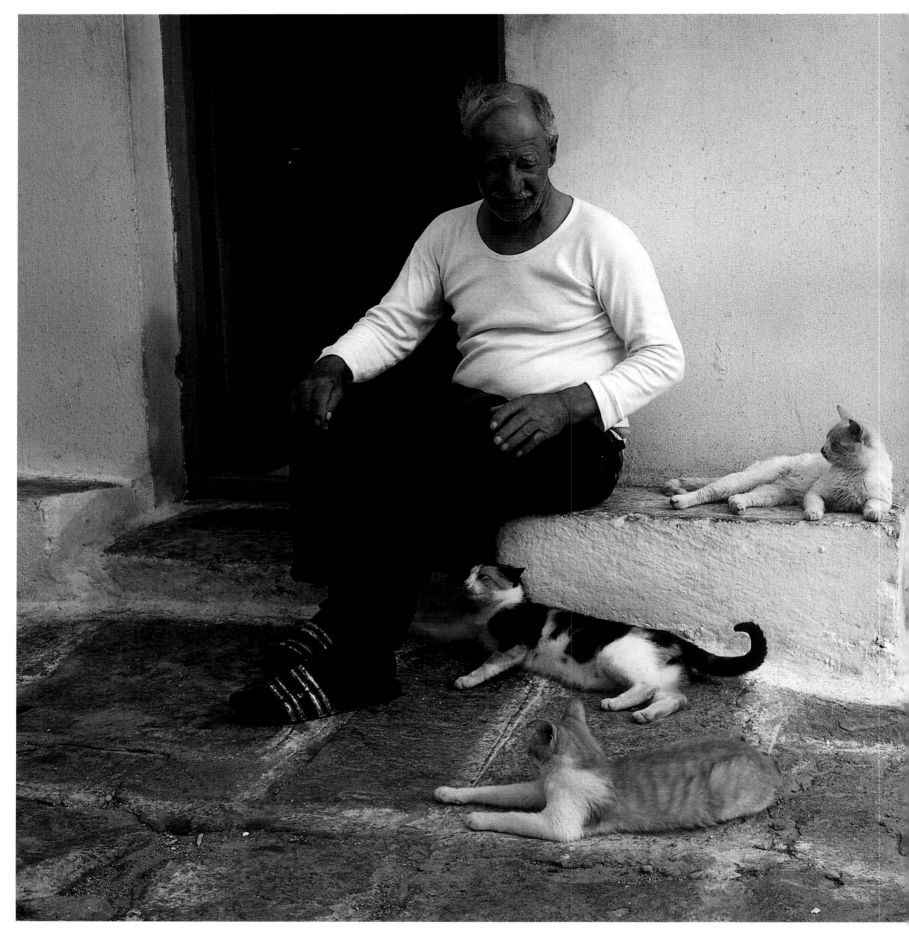

The friendship between people and cats has a long and beautiful history. Just think how many children have been thrilled to be given a little ball of fluff to hold. Not to mention the countless adult cats that have earned the admiration of their owners by patiently allowing a child to stroke their fur in the wrong direction, or grab their tails without hissing or showing their claws. And what better show of friendship than the cat who, returning at dawn after a night's hunting and adventure, slips onto its owner's quilt or, better still, snuggles into the welcoming warmth of a pillow? An old country cat knows that there is no better place for a comfortable nap than curled up on its owner's lap as he or she dozes by the fire. Deep down, it knows that this comfort is a well-deserved reward for ridding the house of rats and mice.

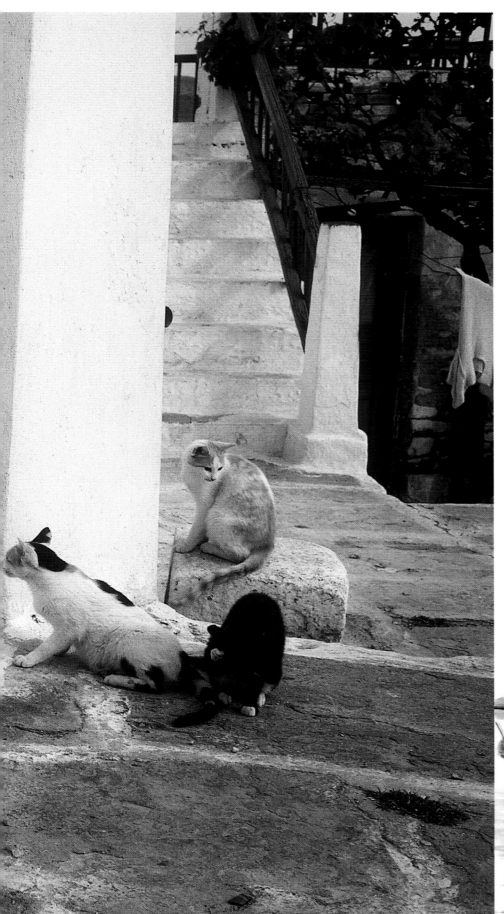

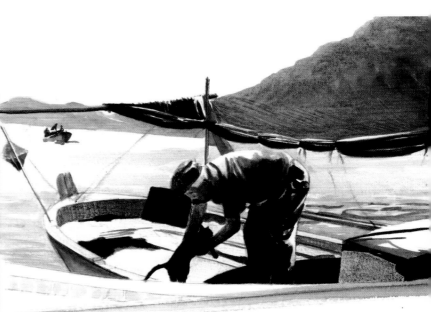

Cats are . . . fierce

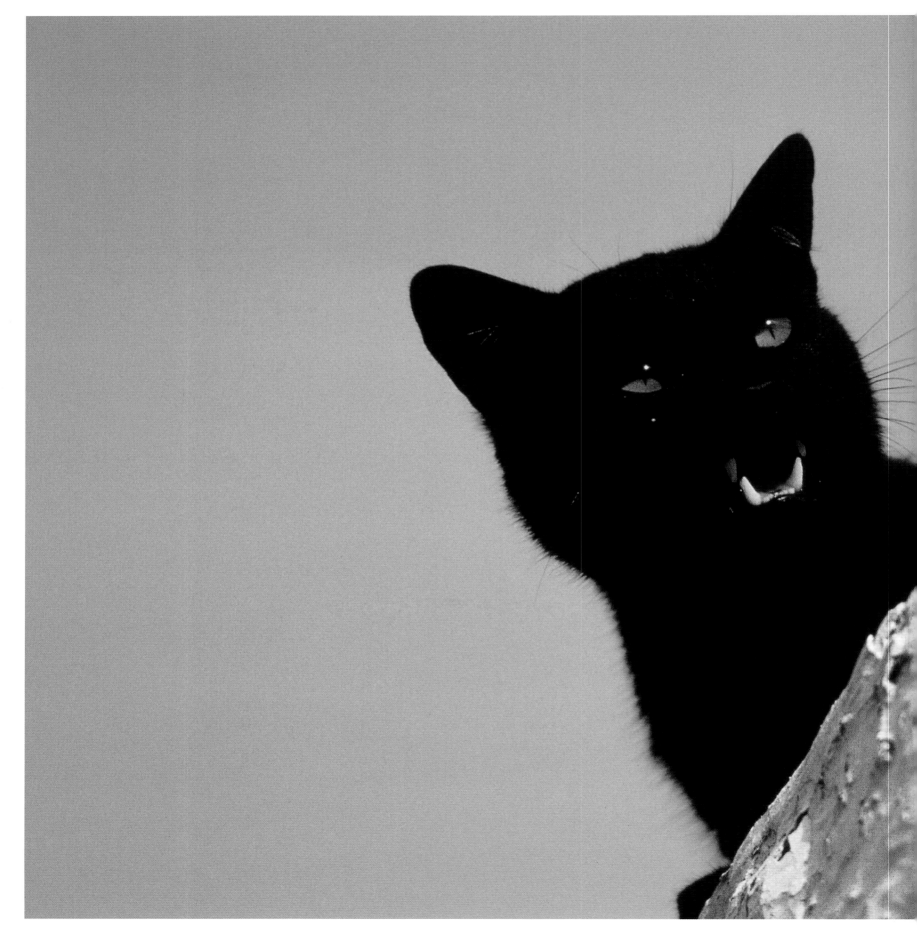

When it becomes angry, the normally gentle cat is transformed into a small bundle of fury, and its kinship to the tiger and leopard becomes apparent. It stands its ground by stiffening its front paws and arching its back, rather like the poses of the bronze cats of ancient Egypt. With its fur bristling and its ears pricked, it makes itself look bigger than it really is. Since the cat can't roar like the lion, it hisses and spits with terrifying effect. The enemy has been warned and had better take note. Suddenly, the cat springs forward with lightning speed. Those terrible claws come into play, razor-sharp needles that leave long, bloody gashes. When fighting in close quarters however, especially with another cat—a rival or gate-crasher—a cat will bite. When it comes to dealing with dogs, often a simple display of hatred will make the canine enemy think twice. Dogs are very good at chasing cats but are not always sure—and rightly so—that they would come out ahead in face-to-face combat.

Cats are . . . sleepyheads

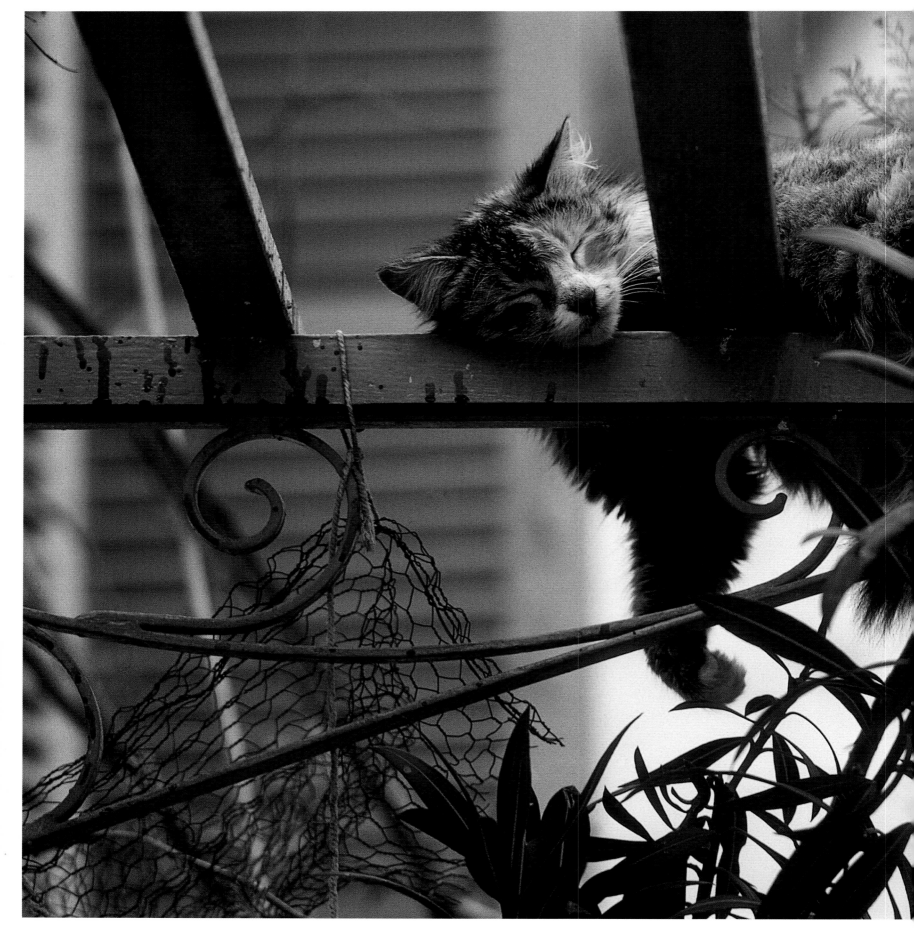

As far as we humans are concerned, night hours are generally a time for rest and sleep. And, as scientific experiments have proven, even though we are asleep, we are still experiencing things in the form of dreams. Perhaps cats dream about the soft nest of their infancy, but more likely their dreams are full of hunting adventures, and of tracking and ambushing their prey—mice, birds, and pretty butterflies.

Cats can sleep anywhere and at any time. They take short naps throughout the day, since they love roaming around after dark. Knowing that these naps are vital to restore their strength and sharpen their hunting skills, they seek out the best and most comfortable spots for a siesta. In summer, they may sleep high up where the air is fresher, whereas in winter, a sheltered corner will provide a cozy bed. Acting as their own personal trainers, these feline athletes know how to keep themselves in top form.

Cats are . . . clean

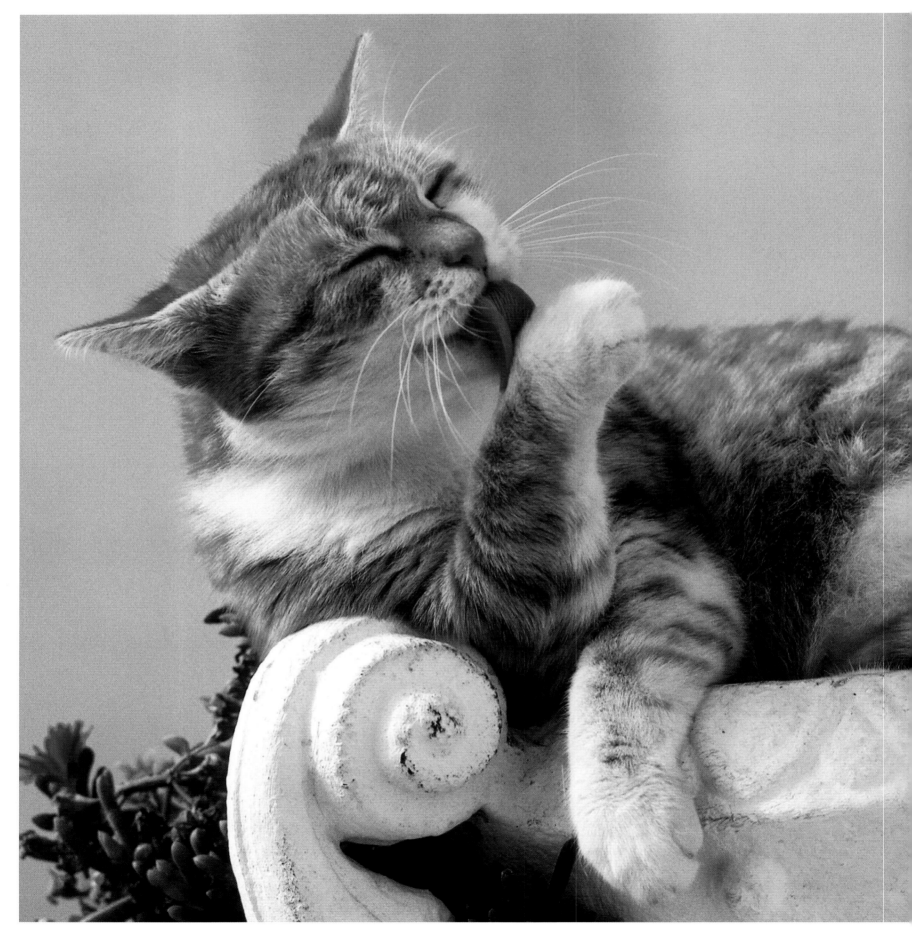

The cleanliness of the feline race is legendary. Everyone knows that cats spend much of their time washing themselves. For creatures that like water—such as dogs, pigeons, or starlings—the solution to getting clean is easy: They can simply have a bath. But cats hate water. Instead, they wash themselves with their rough tongues, moistened with saliva. They are meticulous, cleaning every little bit of their beautiful fur coats. They don't even miss the pads of their paws—you can seldom accuse a cat of walking on a newly polished floor with dirty feet. The tiny grains of dust that their tongues pick up as they wash themselves just pass through their digestive systems. However, the fur that they also pick up when washing can irritate their throats and is usually coughed up in a fur ball. Apart from its head and chest, the cat can reach every part of its body with its tongue, even though this involves some amazing contortions and amusing acrobatics! One scientific theory has suggested that cats dislike water because it erases the static electricity in their coats. Perhaps the static contributes to their sixth sense?

Cats are . . . thoughtful

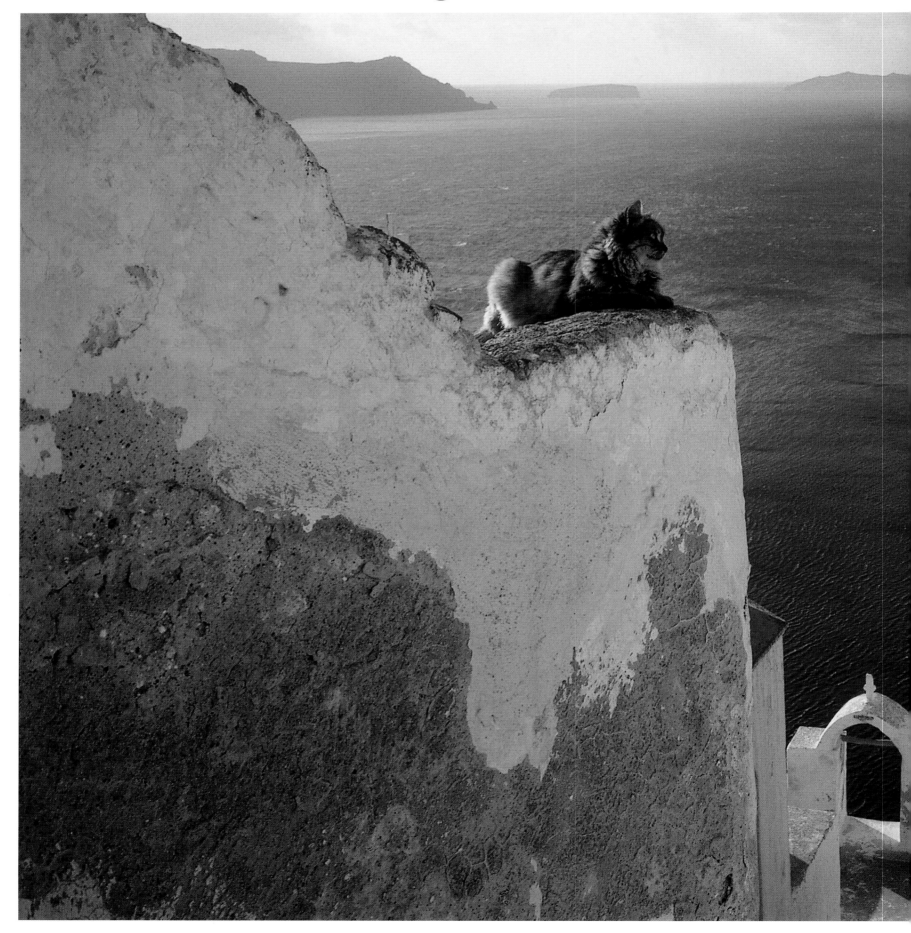

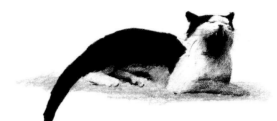

This photograph is a wonderful image of tranquility, eternity, and the vastness of the sea. The cat is obviously daydreaming—replete, relaxed, and with nothing to do but wait for whatever the evening may bring. Separated from our four-legged friends by the absence of a common language, we can't know what they are thinking or see the world through their eyes. However, we can communicate through a feeling of closeness and affection.

It is warm and the cat is dozing, digesting its meal, at peace with the world. And isn't watching the changing landscape, and the general comings and goings of people and their pointless activities—without the slightest concern— just the perfect way to relax before returning to the struggle of everyday existence?

The cat's gaze is distant, vague, disinterested—the exact opposite of when it is hunting and totally focused on its prey. The thoughtful and tranquil versus the alert and active—both sides of the cat's nature complement each other perfectly.

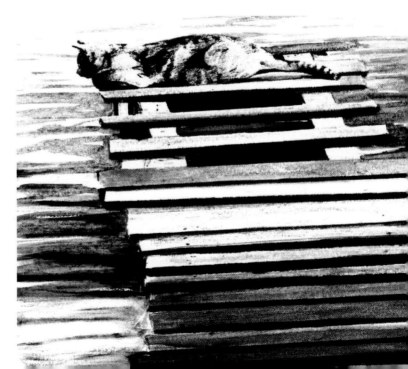

Cats are . . . comfort loving

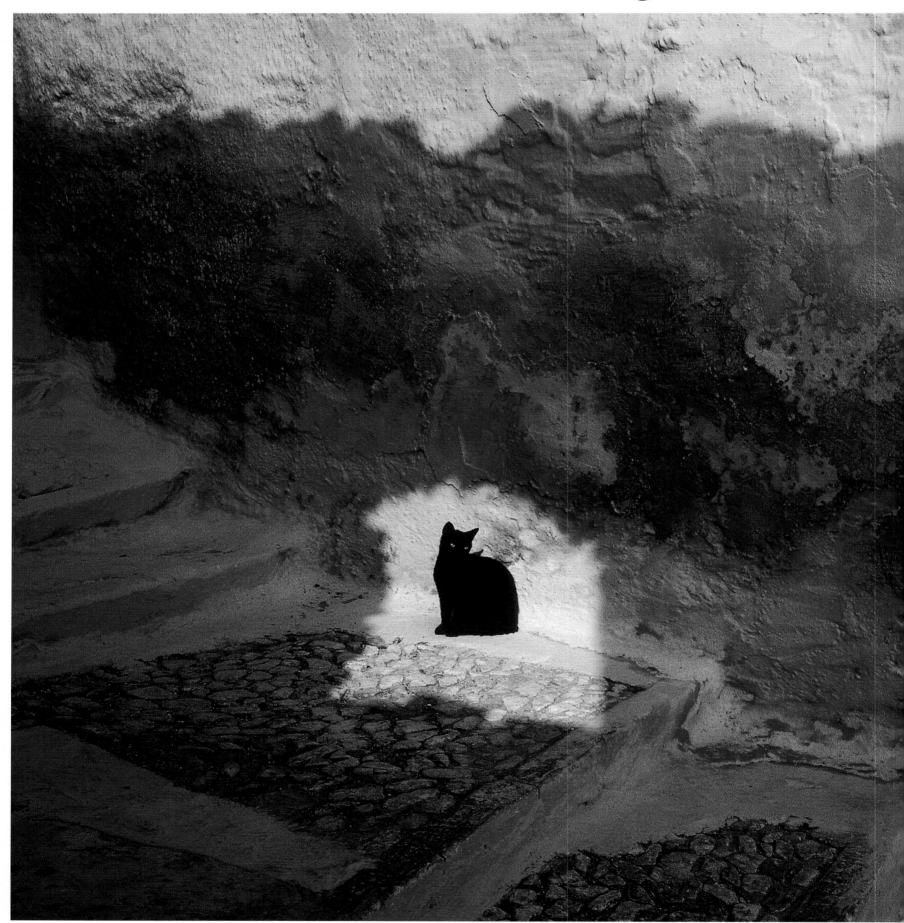

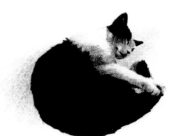

Cats are extremely demanding when it comes to comfort. There's no point in suffering in a cold, damp, smelly place, or being irritated by the wind, hot sun, or noisy activity of people when you could be somewhere comfortable. Cats are good at associating time and place—when they find a particularly comfortable spot, they remember it. Just look at this Greek island cat at left—he has obviously made a mental note of the location and the time of day and is sitting fair and square in the "window" of sunlight created by a hole in the wall. He noticed it and remembered it—and now it's a closely guarded secret. He returns here to sit in the sun at the same time every day, and when it gets too hot, he'll find a shady corner. As far as seeking out comfort is concerned, he has it down to a fine art.

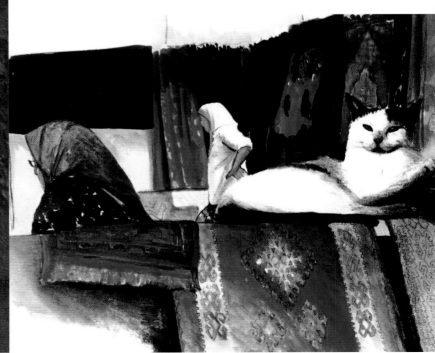

Cats are . . . cautious

Cats are wary of everything and everyone. As far as dogs are concerned, their wariness is not misplaced, since man's other best friend views cats as fair game. But when it comes to strangers, cats are cautious at first, then, depending on their temperament, they may become bold enough to show interest and signs of friendship. Cats are generally more at ease with children from the start.

This caution is evident in other areas of a cat's life. When entering somewhere unfamiliar, the cat scouts around with paws and whiskers. Making use of all its senses—sight, smell, hearing, and touch—it takes full note of the new surroundings. Afraid of being cornered with no way out, a cat always has an escape route lined up—whether it's a cat door, a hole in the wall, a bush to hide under, or a tree it can scramble up, the cat knows how to get out of harm's way.

Cats are . . . hunters

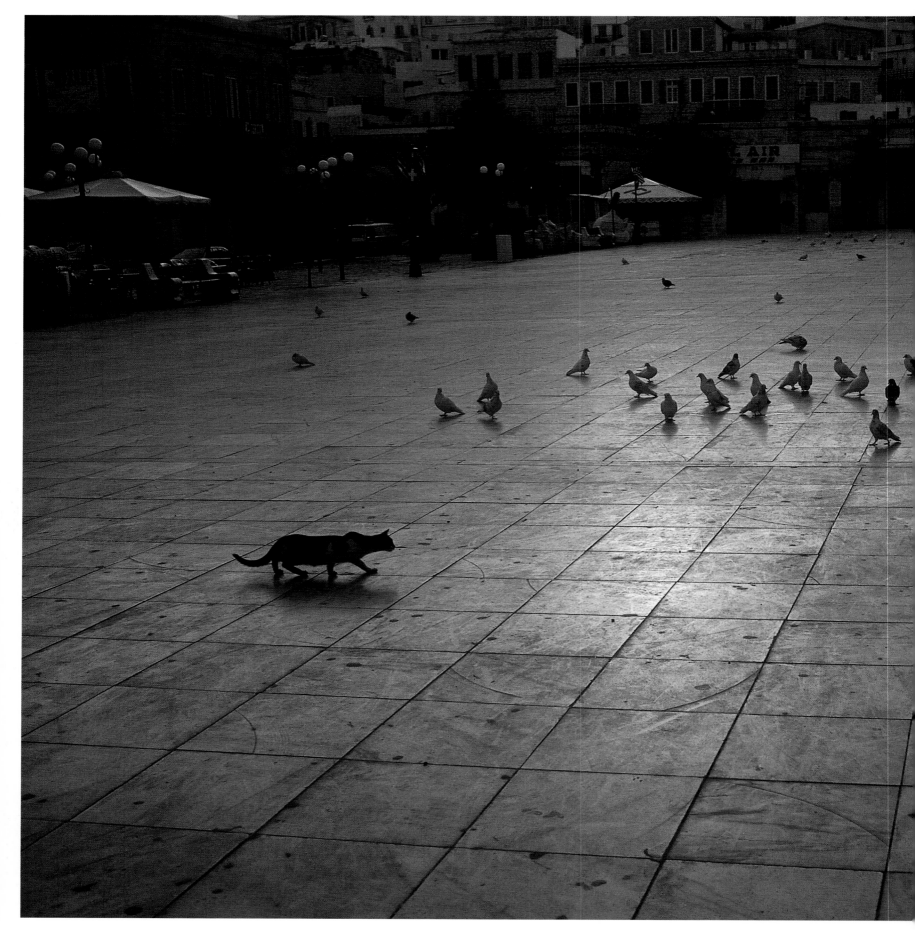

Cats are hunters by nature, but not all cats hunt for food. Cats hunt for the sheer pleasure of watching and waiting, then tracking, catching, and picking over their prey, bringing it home and perhaps eating it. Hunting is a form of training, an exercise that keeps them in shape, a way of refusing to acknowledge that they are growing old.

Real hunting means locating, tracking, and catching mice and other small animals—a healthy cat can eat eight to ten mice a day. Domestic cats sometimes present their catches to their owners as a sign of affection, but the cats of the Greek Islands don't belong to anyone. These cats hunt to live and devour every last morsel of their prey. A few distracted or unwary fledgling birds can also fall victim to the island cats. But hunting birds is not always successful. A cat might spend a whole morning watching a pigeon, only for the hunt to end fruitlessly as the bird flies away unharmed. The sight of a butterfly causes great excitement, simply because it moves, quivers, and flutters. And what about mock hunts? When a cat charges about chasing absolutely nothing through the long grass, perhaps that, too, is a training exercise.

Cats are . . . artistic

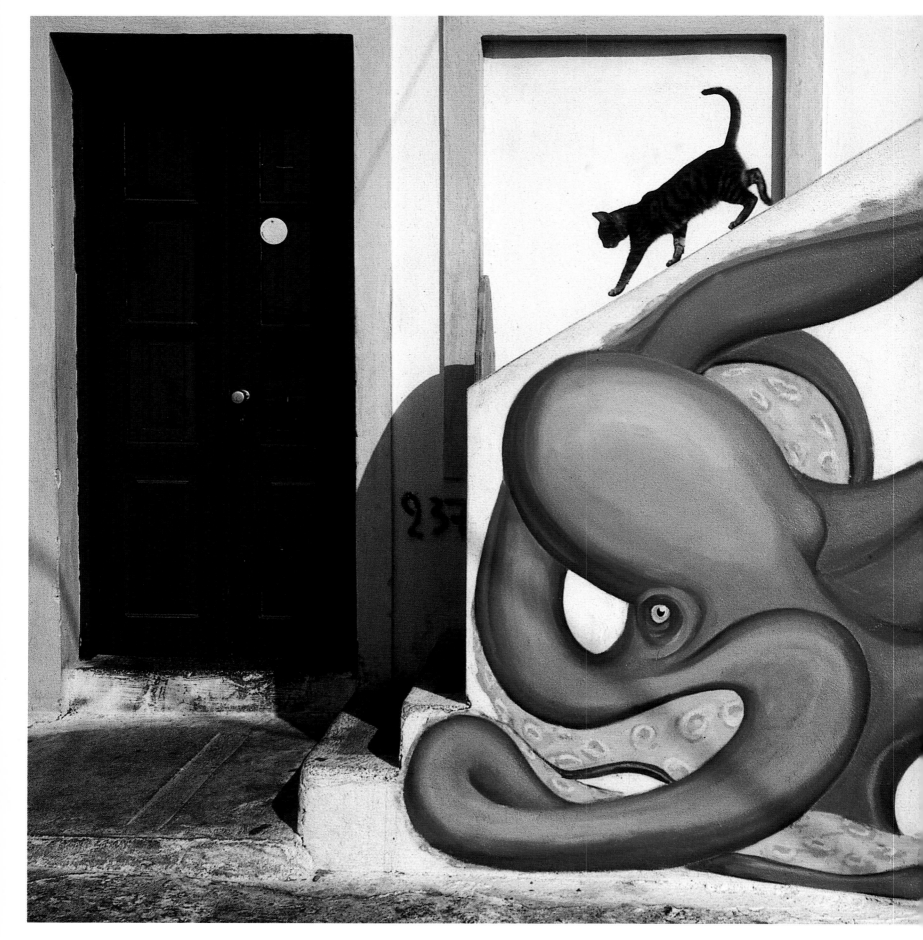

Traditionally, Greek restaurants, cafés, and stores have brightly painted signs—often the work of professional painters who travel around offering their services, or of local amateur artists. The painter of the sign in this photograph has certainly succeeded in catching the eye of passersby, with a giant blue octopus. Though squid is regarded as a delicacy in Greek cuisine, the octopus, believed to be able to assume various forms, was the symbol of intelligence for the ancient Greeks.

A passing cat remains oblivious to this menacing image, and goes about its business with supreme indifference, knowing it has nothing to fear. However, this cat does know how to show itself off to advantage. After this photograph was taken, it settled down in front of the sign, completing the picture. If this cat were to visit the Louvre Museum in Paris, it would head straight for the *Mona Lisa*.

Cats can be . . . naïve

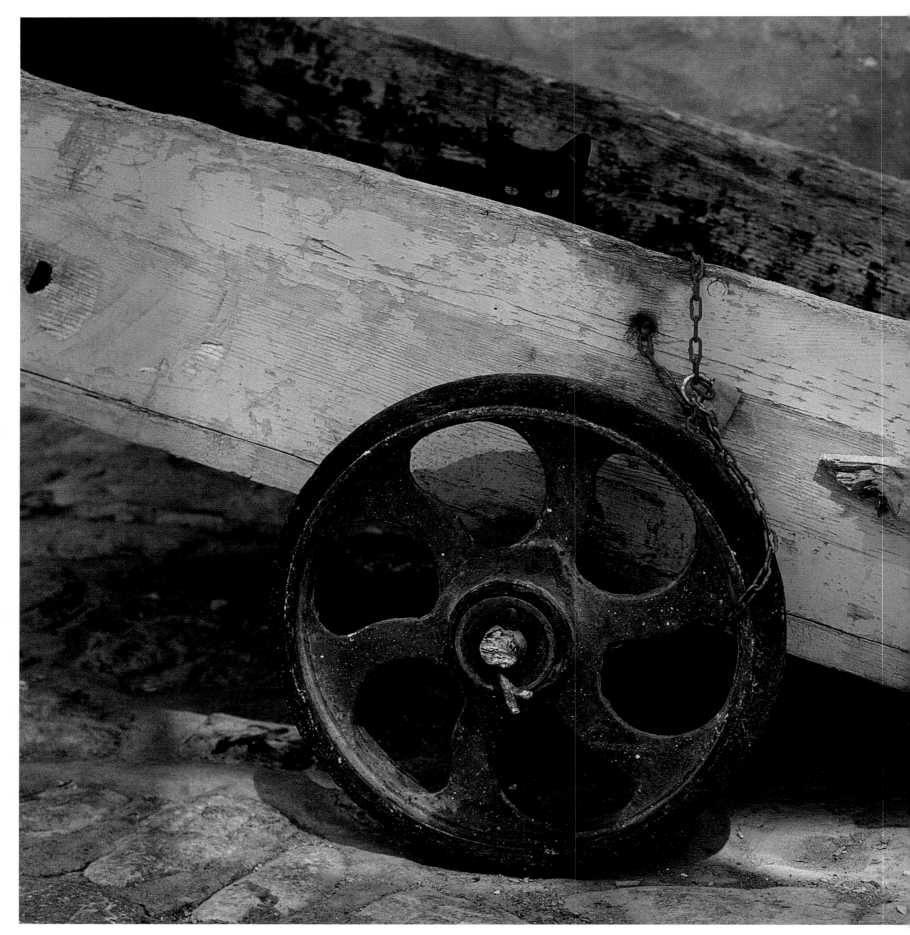

On the whole, cats are smart, cunning, lively, and elusive, but they can also display a comical innocence Take the sulky, disgruntled cat trying to hide from its owners in a tall cupboard—it makes the mistake of leaving its tail sticking out!

Partly hidden by the board of a rustic cart, this black cat at left thinks that no one can see him. He doesn't realize that, because they are not camouflaged like those of a hare or partridge, his yellow eyes set against the black of his fur are as visible as lights in the darkness. Perhaps he feels like a sentry guarding the lookout on a rampart, behind the screen-like board. And who knows where his imagination will take him from there . . .

Cats are . . . great yawners

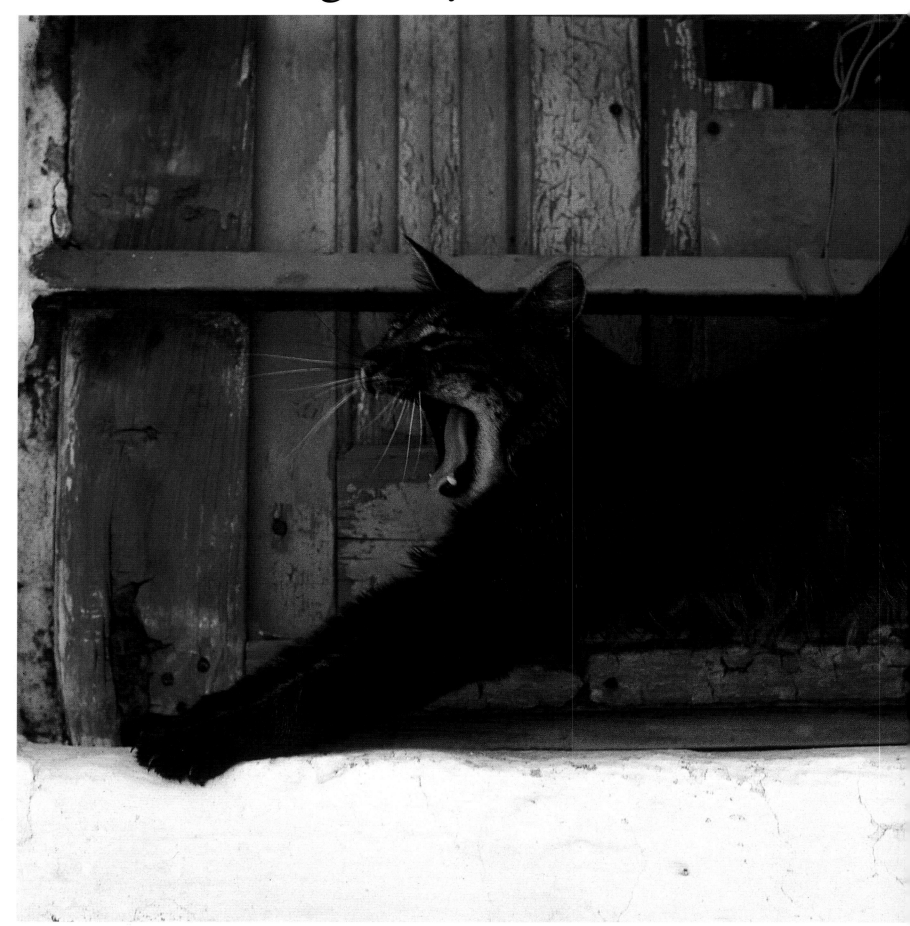

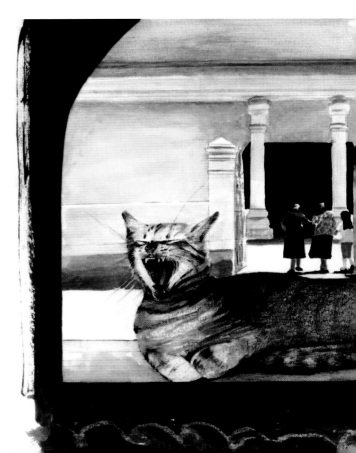

Anthropomorphism is a big word that you don't come across every day. You may find it difficult to remember and think it is therefore best left to the scientists. But when you learn that anthropomorphism comes from the Greek words "anthrôpos," meaning "man," and "morphê," meaning "form," you'll see that it means treating animals as if they were human, pretending they can display the same feelings and reactions, and even that they can speak.

So, if you think that a cat is yawning for the reason a person would, because it feels sleepy, you would be quite wrong.

Cats nap throughout the day and night, but when they wake up, they want to be alert and ready for action. They stretch their muscles and extend their claws to make sure they are in good working order. Their jaws, which before too long will be munching on a mouse or two, also need to be exercised after the relaxation of sleep.

Cats are (sometimes) . . . a dog's best f

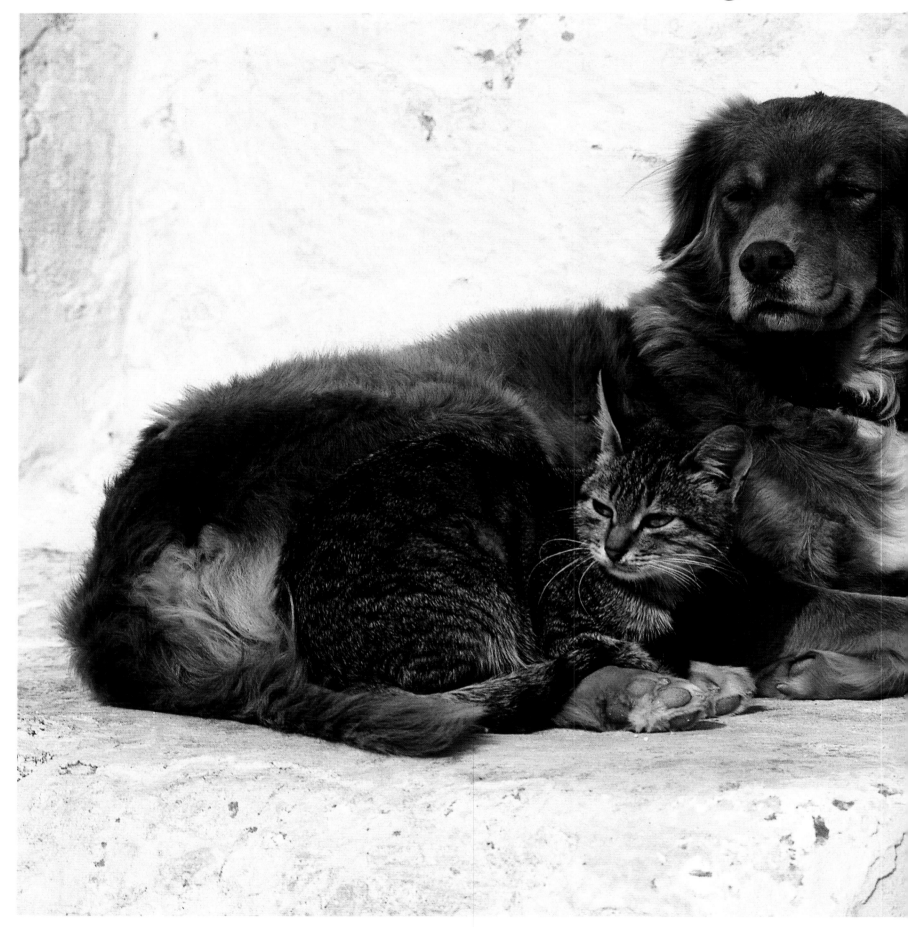

iend

In a letter to the nineteenth-century French novelist Alphonse Daudet, his friend Robert Helmont described a rare display of affection between a cat and a dog. Helmont was stranded in the country with a broken leg. He was getting used to the presence of deer and wild boar in the forest nearby, but then something extraordinary occurred, involving two much more domesticated animals. His neighbor's dog came scratching at his door and, when Helmont opened it, seemed genuinely pleased to see him. He gave her something to drink and fed her a few scraps to eat, but she was restless and kept looking up at him, obviously wanting him to follow her. Helmont's first thought was that the dog wanted to take him to a rabbit that she had caught in the forest, but he turned out to be quite wrong. What the dog brought to him, gently setting it on his doorstep, was no rabbit, but a tiny gray kitten. Greatly touched, Helmont told Daudet, "I think we may need to rethink the expression 'to fight like cats and dogs.'"

Cats are . . . quarrelsome

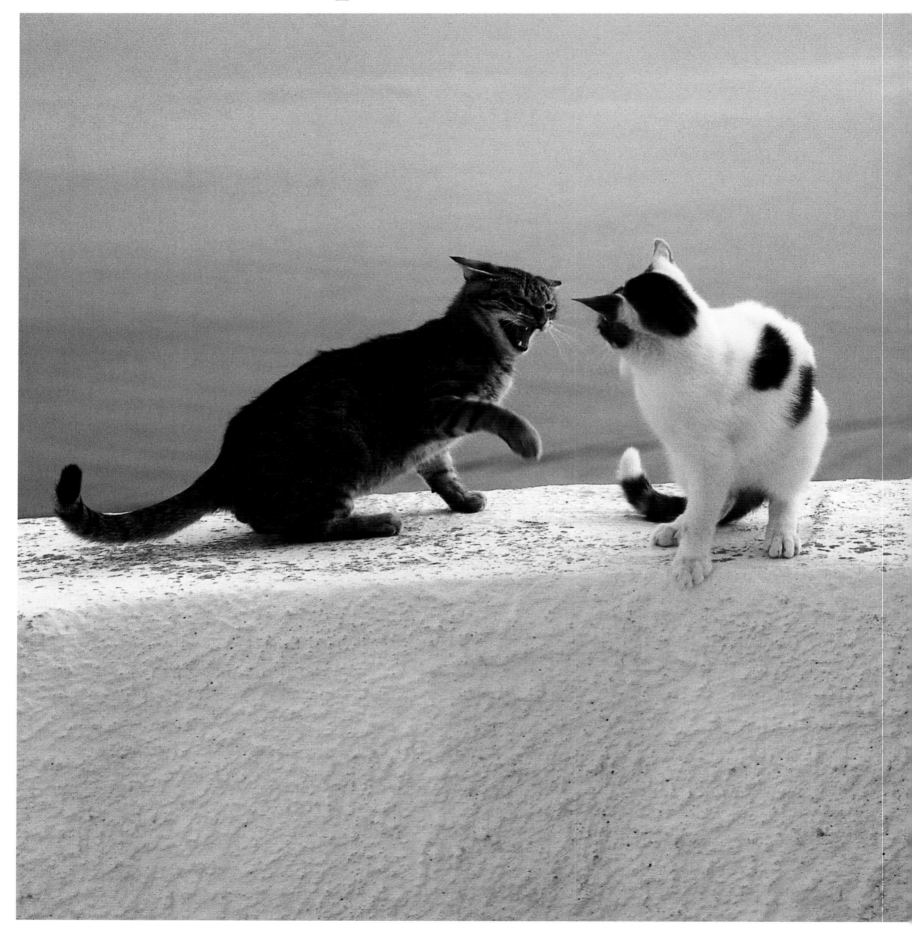

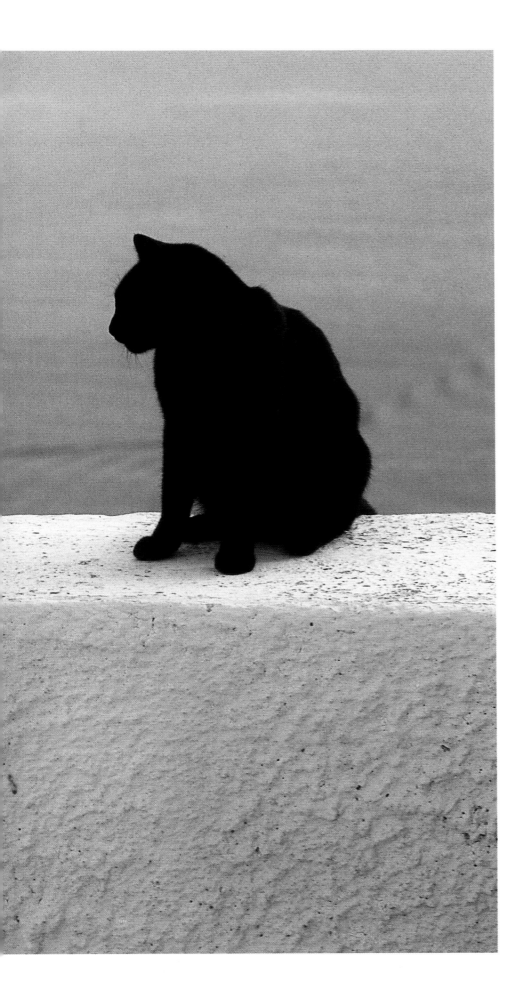

Most people argue—sometimes quite seriously and sometimes over nothing. Cats can be quarrelsome too, and, just like people, sometimes for no real reason. Often it's a question of personal pride—"Get down from there," "I want to sit here," "Don't talk to me like that." If they don't get the desired response, there'll be a fight.

In the following case, the argument was caused by something quite minor. Two cats were sitting in the sun on a high wall that provided a good view, just the sort they like. But along came another cat who mistook the wall for a street! Even if all he was doing was walking past, he annoyed our first two cats. He just had to get down and get back up further along, because they wouldn't let him pass.

Cats fight other cats for a variety of reasons, from a disagreement over a preferred napping spot to crossed boundaries to defending their territory. However, they also fight for other, less well-known reasons: to keep active and trim, and to assert themselves as brave hunters.

Cats are . . . invasive

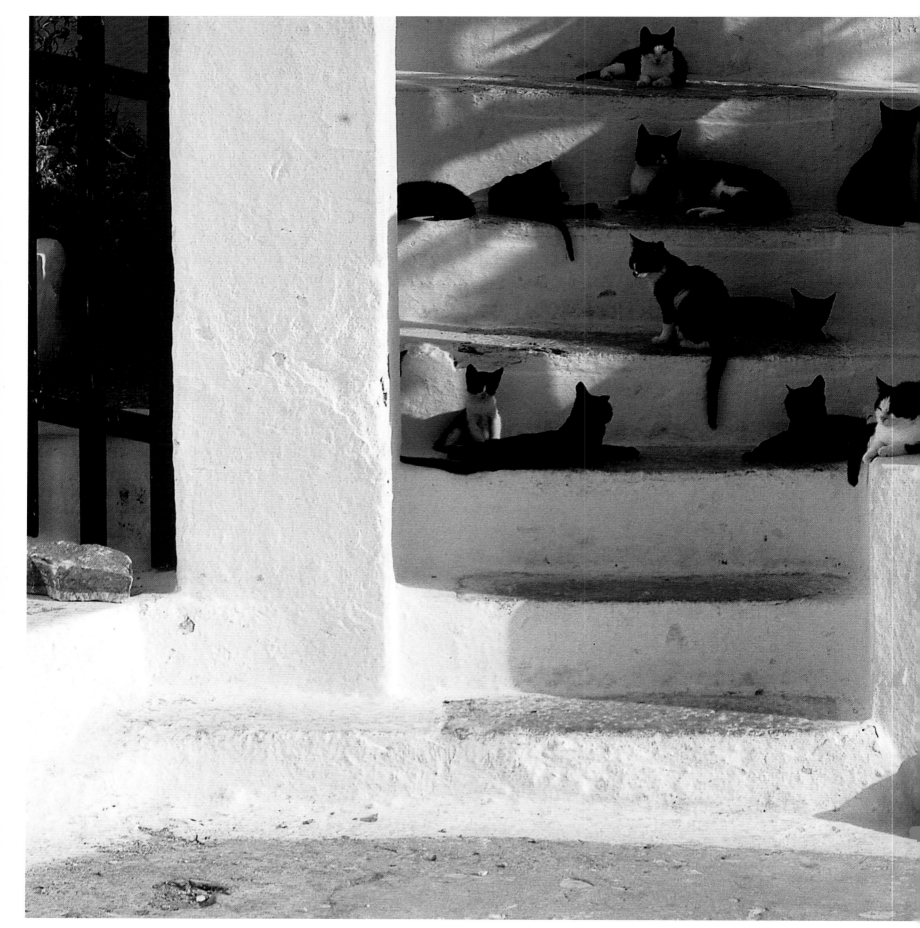

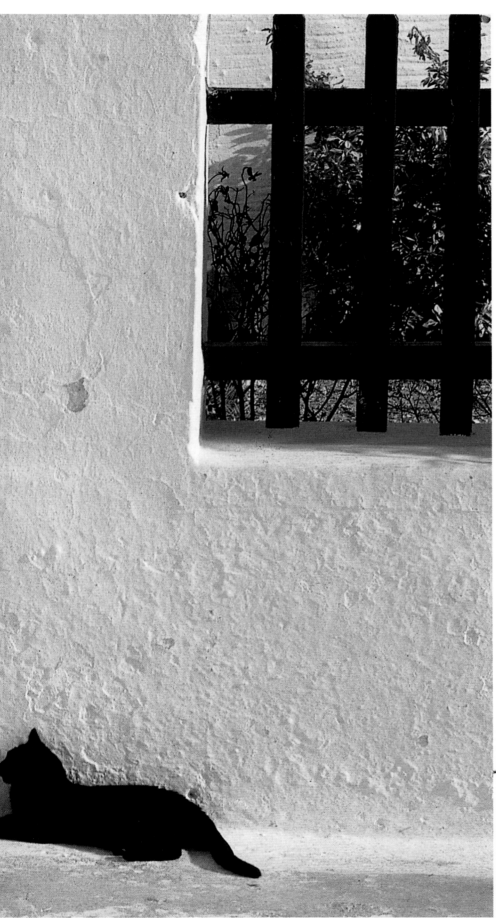

A female cat can have two or three litters per year, with between two and six kittens in each. So it should come as no surprise that the cat population can multiply quickly. Although sustained by the local fishing industry, the cats of the Greek Islands are semi-feral (that is, semi-wild) and like to wander about in groups. These groups can quickly grow to the size of small tribes, divided into families and clans. Early in the morning, if you watch carefully, you will see the local cats go in search of scraps discarded by fishermen in the fishing villages before returning to their own neighborhoods. Not everyone on the islands takes kindly to this wholesale invasion. It certainly has its disadvantages—the cats make a lot of noise at night, they pilfer, there is the threat of disease, and sometimes you might come across a dead cat. As a result, the Greeks, like most southern Europeans, often adopt a harsh attitude toward animals, especially cats. They are usually quite happy for nature (cold, bad weather, disease) to take its course and keep the cat population down.

Cats are . . . affectionate

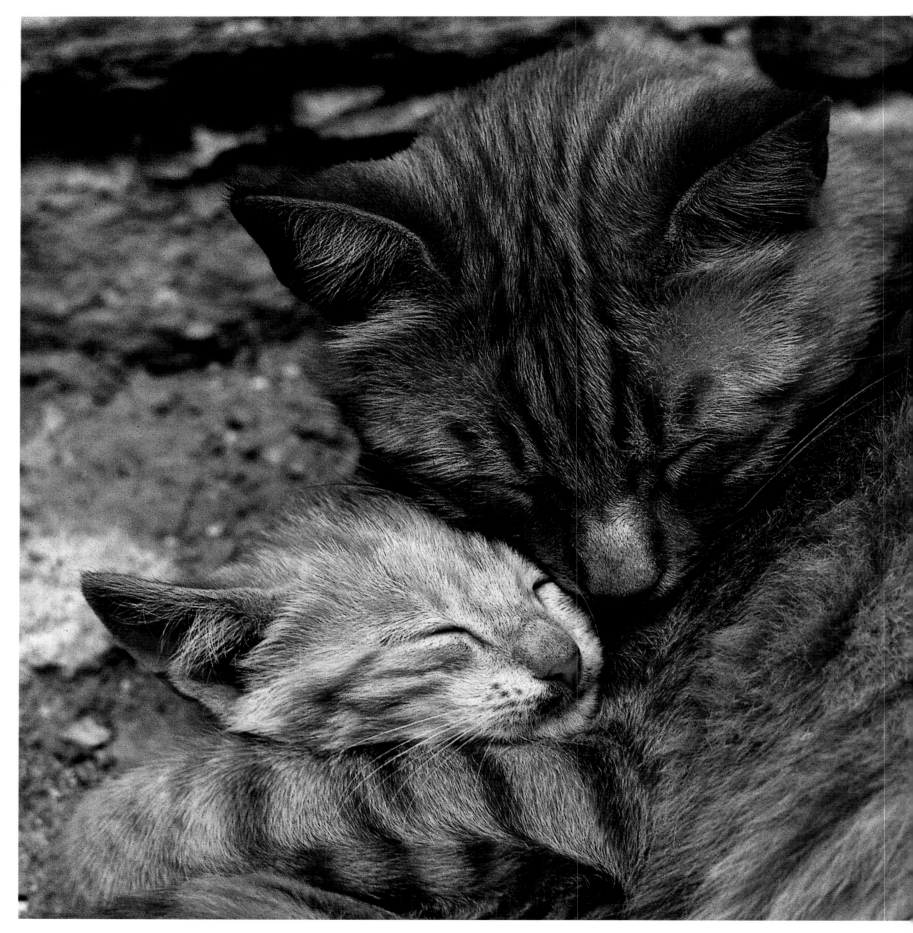

Cats are extremely affectionate. For the female cat, affection is the ultimate happiness. Although an end in itself, it is also something more: a form of intimacy. As this mother cat hugs her kitten close to her—the kitten is protected, it is purring, and the mother can feel the vibration against her cheek—her tenderness is boundless. With their eyes closed and nothing to distract them, they are a picture of warmth and happiness. The mother is full of drowsy tenderness. She is reliving the feeling of affection that she felt near her own mother, which gave her the desire to repeat this pleasurable experience again and again.

Cats show their affection in many different ways. For example, they are patient with children who handle them too roughly or stroke them against the grain of their fur. In the early morning, after a night filled with cat business, they show affection and pleasure at being back home by snuggling gently against the shoulder of their sleeping owner.

Suggestions for Further Reading

Books

The Cat Owner's Manual: Operating Instructions, Troubleshooting Tips, and Advice On Lifetime Maintenance. By David, Dr. Brunner, Sam Stall, Paul Kepple (illustrator), and Jude Buffum (illustrator). Quirk Books, 2004.

Cat Breeds of the World (Illustrated Encyclopedias). By Paddy Cutts. Lorenz Books, 2000.

Know Your Cat: An Owner's Guide to Cat Behavior. By Bruce Fogle. Dorling Kindersley, 1991.

What Is My Cat Thinking?: The Essential Guide to Understanding Pet Behavior. By Gwen Bailey. Thunder Bay Press, 2002.

The Humane Society of the United States Complete Guide to Cat Care. By Wendy Christensen. St. Martin's Press, 2002.

Cats for Dummies. By Gina Spadafori, Paul D. Pion, Dr. Paul D. Pion, Lilian Jackson Braun. For Dummies, 2000.

Cats: How to Choose and Care for a Cat (American Humane Pet Care Library). By Laura S. Jeffrey. Enslow Publishers, 2004.

Web Sites

www.thecatsite.com/
Resources and information on caring for your pet

www.aspca.org
Articles on pet care and nutrition

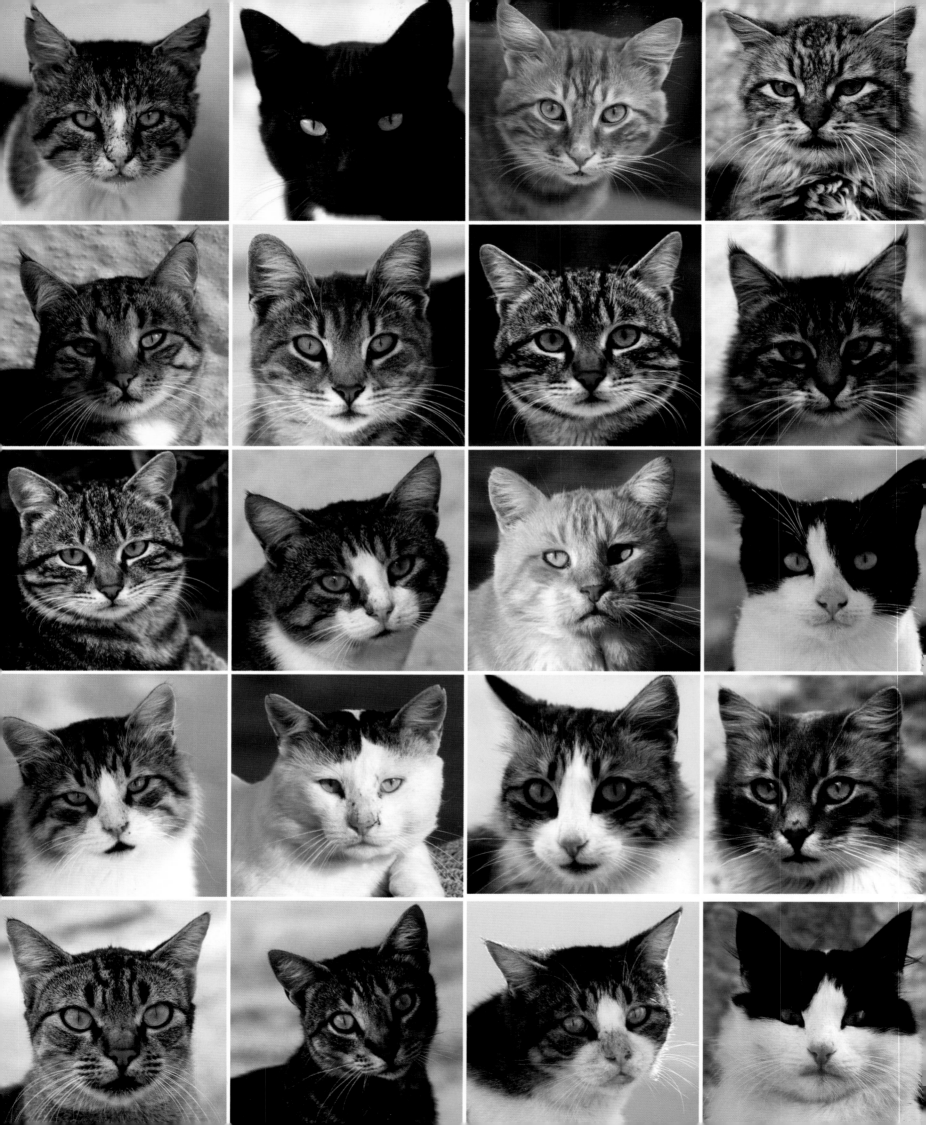